T0303520

CELEBRATING
CORK

KIERAN McCARTHY

AMBERLEY

Dedicated to front-line workers who faced down Covid-19

Front cover image: Grand Parade, Cork, *c.* 1935. (*Irish Examiner* Photographic Archive)

First published 2022

Amberley Publishing, The Hill, Stroud
Gloucestershire GL5 4EP

www.amberley-books.com

British Library Cataloguing in Publication Data.
A catalogue record for this book is available from the British Library.

ISBN 978 1 4456 9746 8 (print)
ISBN 978 1 4456 9747 5 (ebook)

Typesetting by SJmagic DESIGN SERVICES, India.
Printed in Great Britain.

Contents

Introduction

Celebrating Cork is a publication which explores some of the many reasons why Cork is special in the hearts of Corkonians and visitors. This book was penned in the spring and summer of 2020, when the Covid-19 pandemic challenged the resilience of every city and region across Ireland and Europe. For the tragedy and sickness it brought, it also brought out the best of volunteerism, rallied communities to react and help, and saw neighbours helping neighbours. The importance of community life is no stranger to any Irish neighbourhood but the essence of togetherness in Cork at any time in its history is impressive, and more impressive is that it has survived against the onslaught of mass globalisation and technological development. So this book is a nod to the resilience of Cork; to community life, togetherness and neighbourliness. It is also a huge thank you to the front-line workers of our time and to the myriad of community response teams who helped people get through such a challenging period in our history.

Celebrating Cork builds on my previous publications, notably *Cork in 50 Buildings*, *Secret Cork*, and *Cork City History Tour*, all published by Amberley Publishing. This book focuses on different aspects of Cork's past and places more focus on elements I have not had a chance to write upon and reflect about in previous publications. With more and more archival material being digitised it is easier to access original source material in antiquarian books or to search through old newspapers to find the voices championing steps in Cork's progression in infrastructure, community life or in its cultural development.

More and more I am drawn to a number of themes which I continue to explore in publications. As a city on the very edge of Western Europe, and as a port city, Cork has always been open to influences from Europe and the world at large. Cork's Atlantic-ness and that influence, whether that be location, light or trade, is significant. Corkonians of the past were aware of the shouts of dockers and noise from dropping anchors, the sea water causing masts to creak, and the hulls of timber ships knocking against its wall, as if to say 'we are here', and the multitudes of informal international conversations happening just at the edge of a small city centre.

Cork's ruralness and its connections to the region around it, especially the River Lee and Cork Harbour, is a theme that I have been actively writing about for over a decade. There are certainly many stories along the river and estuary which have been lost to time and Cork's collective memory. Cork's place as a second city in Ireland and its second city engine is an important factor of the city's development, both in the past and for the future.

Cork's construction on a swampland means that its buildings are not overly tall. Merchants and residents throughout the ages were aware of its physical position in the middle of a marshland with a river, and knew it would require hard work to reclaim the land. I like to think they saw and reflected upon the multitudes of timber trunks being hand-driven into the ground to create the foundations of the city's array of different architectural styles.

Cork is a stronghold of community life and culture. Corkonians have a large variety of strong cultural traditions, from sports and commerce, to education, maritime, festivals, literature, art, music and the rich Cork accent itself. *Celebrating Cork* is about being proud of the city's and its citizens' achievements, attained through hard work, passion and working together.

Enjoy,
Kieran McCarthy

Daly's Bridge, aka Shakey Bridge, January 2021. (Kieran McCarthy)

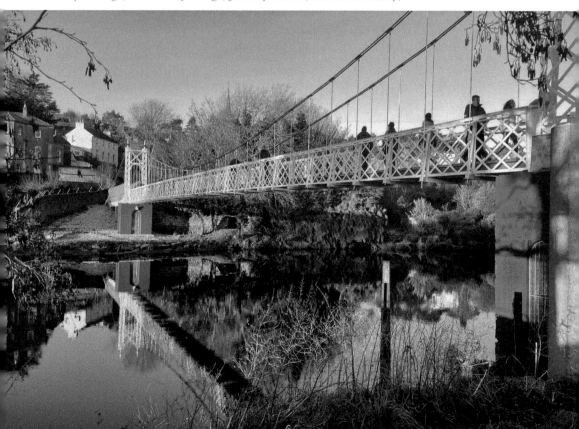

The Fabric of a City

The Atlantic Light

Cork's location in the North Atlantic is a core aspect of the city's identity. The Atlantic light is very important to Cork and its soul – its mood, its urbanity and its very character. I have long marvelled at how the Atlantic light in Cork can change the atmosphere and feeling of the city, through beautiful sunrises and sunsets, heralding the advent of day and night. The scenes created prompt one to wonder what lies beyond. The Atlantic light brings small playful beams which drive the imagination and fuel a personal connection to the landscape.

I love photographing how the Atlantic light illuminates parts of the River Lee and its quaysides, bridges and walkways, different neighbourhoods, parts of street corners, parts of buildings, parts of our valued and shared cultural heritage. The light varies at different points of an hour, day or a season.

The city's past, present and future narrative is enlivened by light. The position of the sun in the sky and its qualities of light all create and enhance Cork's urban landscape. This illumination of the city is also enhanced by the limestone buildings which light up when the light hits them and go very dull when grey clouds prevent beams of light from getting through. Cases in point are the beautiful and imposing structures such as the thirteenth-century Red Abbey Tower, the seventeenth-century Elizabeth Fort, the nineteenth-century structures of the Quadrangle in UCC, St Finbarre's Cathedral, the North Cathedral and Shandon's St Anne's Church, Blackrock Castle. All are very photogenic when the sunshine illuminates them.

It is something to remark upon that even how the city developed – its buildings and their windows, and the direction they face – is linked to the light. Light and shade are important factors when examining the city's most beautiful interiors. Take for example some of the oldest structures in the city still standing from the early eighteenth century, and the oval Georgian fanlights above their doors. Details such as these helped light the space in the age of candles.

The interior of what is one of my favourite buildings, the Honan Chapel in UCC, has an array of stained-glass windows of Ireland's regional saints, by

famous stained-glass window makers Harry Clarke and Sarah Purser. The light is refracted through the glass onto the floor and interior walls of the chapel, casting different colours onto the epic mosaic called the *River of Life*.

Such obsession with light is also reflected on the walls of our art institutions, such as the Crawford Gallery. Check out its sculpture gallery of nineteenth-century casts and how the light flickers on them, illuminating their almost movement and animation if you look at them for a sustained period of time. Light also flickers across the wider collection of paintings in other galleries. In addition, in many of the Cork paintings, the Atlantic light is very much depicted in romantic terms. One such painting is that by the artist John Butts from 1760, whose picture *View of Cork* encompasses rich watercolours but is painted at a point in the day when one part of Cork was enlivened and other parts are not. The painting depicts a detailed landscape view or a highly complex composition showing a profound study of knowledge of landscape. The depth and space were further highlighted through the use of contrasting warm and cool colours rather than light and shade. But what I describe is only scratching the surface of Cork and its relationship with light.

Sunset at the Marina, April 2009. (Kieran McCarthy)

Tower of St Anne's Church, Shandon, July 2014. (Kieran McCarthy)

A River and Its Geographies

The River Lee and its catchment area add immensely to the sense of place and how one moves about this place. Undulating tributary rivers feeding the Lee create bends in the road, where one can get a real sense of Cork from its rootedness to the geography around it. With exquisite scenery, winding routeways twisting and interconnecting like memories through the topography, the traveller finds a discovery at every bend of the road in the region.

The catchment area of the River Lee is approximately 440 square miles (1,150 square kilometres). Tree-like in nature, the various tributaries create undulations – dips and rises – cutting through enormous limestone and sandstone ridges to the north and south of the core river valley. The catchment area is more or less rectangular in shape and approximately 30 miles (48 km) long and 14 miles (22.4 km) wide. It can be divided up into two well-defined stretches – one rugged and the other agricultural. The first is the highland section from Gougane Barra to near Macroom, a raw landscape where the traveller can almost still feel the effects of the melting ice at the end of the last Ice Age, 20,000 years ago, scraping and cutting sharply into the landscape, slicing it open and leaving fissures in the rock like raw wounds.

Epochs of glaciations had a huge effect on the land. They determined the surface topography and soils, to which local societies had to adapt through the ages.

Today much of the soils in the western part of the Lee valley are peats and peaty gleys, which are best suited for grazing and forestry. However, throughout the valley, the heritage of the land is significant. The land has provided and continues to provide employment in farming and industrial pursuits. Dairying is an age-old tradition in the valleys of County Cork and the Lee valley is no different. From source to mouth, farming is the principal industry.

The second part of the catchment area is the cultivated scenic area from Macroom to Cork City. There is a marked contrast between the rawness of the highland section and the fertile lands in parishes such as Aghabullogue and Inniscarra through which the Lee flows towards at the end of its journey. Here, the fieldscapes are lush, rolling and highly photogenic. The overall landscape appears as tangled and complex, overlapping and interlocking as one makes the journey across the region. The Toon, Sullane, Foherish, Laney, Glaise, Dripsey, Shournagh, and the Martin are the bulk of the tributaries that drain into the River Lee from the north. While there are many small streams, arterial-like, coming from the south, the main tributary here is the Bride. The major drainage from the north is due to the presence of the Derrynasaggart and Boggeragh Mountains. The Lee from Macroom to Inniscarra is also defined by two wide and scenic reservoirs of the Lee Hydroelectric Scheme created in 1956.

The Lee Fields are an important crossroads where the River Lee's natural wilderness and the urban wilderness of the city collide. It is here that the River Lee splits into two creating a north and south channel; both channels encompass the city centre islands.

Rowing by adjacent Cork Docklands, October 2012. (Kieran McCarthy)

Cork's Lee Fields, January 2020. (Kieran McCarthy)

A City Built on a Swamp

The original name for Cork is Corcach Mór na Mumhan, or the Great Marsh of Munster. Cork City's physical development through reclamation on a swamp – sand and gravel, rushes and reeds – is an amazing story.

The publication *Archaeological Excavations at South Main Street 2003–2005*, edited by Ciara Brett and Maurice Hurley, brings the reader back to a time where the natural environment of forests, the River Lee's estuarine silt and the sheltered harbour were explored and mined for their resources. The earliest Viking settlers of eleventh-century Cork were recycling and land reclamation experts. This publication outlines the results of two large-scale excavations which took place at 36–39 and 40–48 South Main Street. Both sites are located in close proximity to the South Gate Bridge, one of the main entrances to the medieval walled town of Cork. The results of the excavations are significant as they have added to the citizen's knowledge of the formation and development of the city.

There are many fantastic revelations in the latter book about reclamation from the swamp to outlining in detail the material culture from pottery to the use of wood for housing to gaming pieces. The excavations were undertaken by Sheila Lane and Associates and the Department of Archaeology, UCC. The various contributors paint a picture of their respective sites across several centuries.

In particular they place a large focus on Cork in the early twelfth century, a period before the Anglo-Norman invasion. By that time, the Hiberno-Norse, those living in Ireland with a Norse ethnic background, were rooted and settled in places such as Cork, Waterford, Wexford, Limerick and Dublin.

On trowelling back the earth on South Main Street, archaeologists peeled back different temporal contexts. It was 2 to 3 metres underneath our present-day city that they exposed the remains of timber structures lingering, intrusive and protruding, through the mud. These were ruinous, abandoned, broken, segmented, mixed-up, rotting, crumbling, and on the edge of a swamp. The timbers were the sinking roots, cultural products and ideas of a long-lost settlement; an enigmatic space where no written documentation existed bar the variations in the rings of the timbers. The rings alluded to growth and resilience, an age before use and being part of a woodland at one stage in their life. Despite the decay of the timbers, the intensity of construction and some details in the skilled carpentry work remain for all to see.

At this crossroads of time, according to expert David Brown (p.525 in the book), there is an indication from the dendrochronological dates of the timbers found on the site that there was a continuous felling of trees and construction

Archaeological excavations at the Grand Parade City Car Park, October 2003. (Kieran McCarthy)

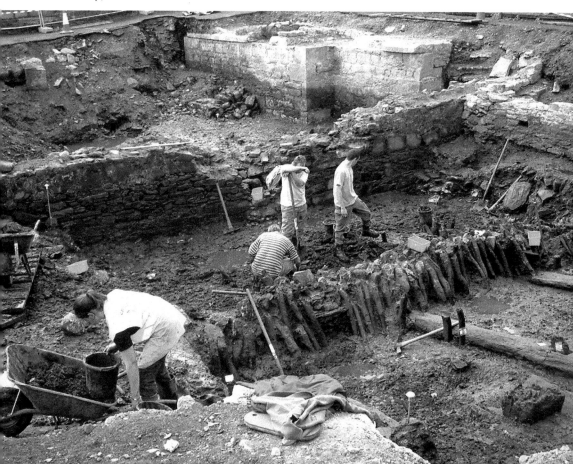

of buildings and reclamation structures from just a few years before AD 1100 to AD 1160. So here on a swamp 900 years ago, a group of settlers decided to make a real go at planning, building, reconstructing and maintaining a mini town of wood on a sinking reed-ridden and wet riverine and tidal space.

One has to admire their vision and tenacity, and of course their legacy is the eventual reclamation of other marshy islands and the creation of the city of Cork.

The Facade of the City

The flag of Cork is red and white and this is linked with Cork's underling rock strata and its series of alternative east–west limestone and sandstone strata. The limestone elevations of St Anne's Church, Shandon, face 'limestone country' to the south and west while the northern and eastern facades face traditional 'sandstone country'. The colours of these materials have long been recognised as the colours of Cork. The bedrock of limestone and sandstone also provides Cork's architectural facade.

The sandstone quarried had two varieties. The first and widely utilised was the Kiltorcan formation: green, grey and red at Brickfield Quarry, Sunday's Well, and the Lee Road. A minor fine-grained sandstone was quarried at Richmond Hill and the Back Watercourse Road.

Reflections adjacent to St Mary's Church, Pope's Quay, December 2019. (Kieran McCarthy)

The ordinary grey limestone that constitutes the chief building stone of the city, especially for public buildings, was worked in numerous quarries around Ballintemple and Blackrock and at Little Island and Midleton. They were also quarried for lime burning to create fertiliser and road mending.

In 1792, when Beamish & Crawford Brewery was first established, co-founder William Beamish resided at Beaumont House, which was then a magnificent period residence situated on Beaumont Hill. During their tenure at Beaumont House the philanthropic spirit of the Beamish family was well known. The name Beaumont is the French derivative of Beamish meaning a beautiful view from the mountain. The mansion house continued to have an association with the Beamish family until the 1850s. The house was eventually demolished and since 1968 Beaumont National boys' and girls' school (Scoil Barra Naofa) stands on its site.

In the Beamish estate, the famous 120-acre Carrigmore Quarry was opened sometime between 1830 and 1850. The particular high grade of limestone associated with this quarry meant it was widely used in the construction of quay walls, bridges, churches, banks and other public buildings within Cork City. This rock is filled with minute fossils, and these, on account of their crystalline character, weather more slowly than the amorphous material surrounding them, and thus we get a beautiful veined appearance.

There is quite an extensive network of caves at the eastern face of the quarry. These caves were first explored in the 1960s by the Cork Speleological Group and a further survey was conducted by the British Cave Research group in the early 1970s. Some of the cave wall passages were found to be abundant in lower carboniferous fossil seashells and crinoid steams.

Architectural Wanderings

Standing atop Cork's suburban hills and looking to the city centre the wide variety of architectural styles is plain to see. But for everything written on Cork's most famous and most beautiful buildings such as St Anne's Church, Shandon, or even the English Market, there is much more not written down. Wandering the streets of the inner city, the walker encounters a wide variety of building design. Much is hidden amongst the city's narrow streets and laneways.

Such a variety of design came from the city developing in a piecemeal fashion, its underlining steep hills and marshland topography and local architects drawing on British and Continental style such as from the Netherlands. The piecemeal development is apparent on maps but can be clearly seen on the ground when one short row of eighteenth-century buildings continues with nineteenth-century ones.

Very little of medieval Cork or post-medieval architecture survives. The most public section of the base of the town wall survives in Bishop Lucey Park. The tower of the Augustinian Red Abbey survives as does the well from the Franciscan abbey on the North Mall.

Much of medieval Cork was replaced by late eighteenth-century expansionists. The population explosion led to a vast number of one-storey cabins aligning with many of the approach roads into the city centre. Demand for merchant housing and warehouse space led to the construction of four-storey-high, pitched-roofed buildings, common along the city's quays such as George's Quay or scattered throughout Oliver Plunkett Street and its side streets or Shandon Street. Much of their story is lost to time, as is the story of those sitting upon a swamp. There is anecdotal evidence surviving of the vast number of long tree trunks driven into the ground which act as foundations of buildings. The weight of many buildings would have pushed many of these foundations further into the ground. Walking through the older quarters of the city, such as Oliver Plunkett for example, one can see buildings leaning back slightly onto their foundations. It is also one of the principal reasons that Cork never constructed tall buildings within the city centre island, and plans for large spires of churches were curtailed.

Dutch slob brick was also used in the construction of the mid-eighteenth-century residential landscape. This brick arrived on ships from the Netherlands and was used as ballast. A similar type of product was manufactured from sand and silt in Douglas Estuary from the early nineteenth century. Red bricks were manufactured in Cork and appeared from the decade of the 1820s and were the principal construction material until the prime age of concrete from the 1920s onwards.

Ever-photogenic as well are the immediate surrounding historic suburbs of the city centre in which a wide range of mid- to late nineteenth-century buildings are varied and colourful. The large network of old stone-built cabins, now modernised on the inside and painted on the outside, can be viewed within the city's inner network of lanes and streets. Examples can be found at sites such as Evergreen Road, High Street, Blarney Street, and off Dominick Street in Shandon. They are reminders that in the past not every citizen benefitted from the commerce of Cork.

Old warehouses at Penrose Quay, April 2020.

The best examples of variety in the mid-nineteenth century middle-class housing are those terraces on Summerhill North and South and semi-detached housing on the Cross Douglas Road. Architectural embellishment was ever present here. Designs sprang from the relationship between social forces, ideals, techniques and individual preference. As the mid- to late 1800s ensued, there was increasing interest in foreign styles, such as French, Italian Gothic and French Renaissance. In most cases, a mixed 'bag' of medieval styles was reinvented. In the late 1800s, the favoured architectural style in housing was High Victorian Gothic, which provided aristocracy and landed gentry with houses that were spectacular and richly ornamented. The Gothic Revival was the first and most important of the many house fashions to sweep the Victorian world, *c.* 1840.

The next fashion was the Italianate, so-called because it looked to the country villas of northern Italy for its inspiration. The style was characterized by a rectangular massing of the body of the house, often arranged picturesquely into asymmetric blocks to imitate the sprawling look of centuries-old villas in Italy that had been modified and enlarged by many generations. The style often featured a square tower or cupola, in which case it is sometimes referred to as 'Tuscan'. The best example in Cork is Montenotte House, adjacent to the headquarters of Cope Foundation.

The next major Victorian house style was the Queen Anne, which dominated Victorian residential architecture from 1880 to 1910 to such an extent that it is now virtually synonymous with the phrase 'Victorian house' to much of the public. The best examples are located on O'Donavan's Road adjacent to the grounds of UCC.

Architectural delights from Lavitt's Quay looking towards Gurranabraher, December 2019. (Kieran McCarthy)

Making a City

The Charters of a City

Throughout the centuries the Cork region has always been an economic stronghold. In published economic histories of Cork in earlier centuries, charters, market places and trade bodies dominate. Continual reference is given to the fact that between the years 1185 and 1900, Cork received no fewer than seventeen charters, all reflecting upon Cork's importance as a key market place and port in Ireland. These official records were legally binding and provide the historical foundations of commercial life in Cork. Many were reactions to what was going on within the wider Anglo-Norman colonies at a point in time. The politics, ambitions and interests of various kings who aspired to advance aspects of their governance were also significant. Many included laws that were also brought to bear on other English settlements.

In medieval times charters encompassed ideas of controlling those who lived within fortresses and walled towns such as Cork. Cork charters influenced laws to improve the town walls, augment powers of mayors, carve up living space within the town, influence commerce, make new trading laws and establish new taxation laws. All tried as well to ease tensions amongst citizens, who felt disillusioned with the elite, and other reckonings such as the deals struck with Gaelic Irish families to keep them in check. Many of the concessions embodied in these charters contributed in no small measure to build up the confidence, the aspiration, the identity and commercial prosperity of the city. Many of the concessions even crossed centuries to inform commercial policy on importation and exportation in the twentieth century.

The earliest records note that as far back as AD 1188 or AD 1189, a charter granted all the laws, franchises and customs of freight 'on whatever sails' to the citizens. There is no doubt that trade between Cork and English ports, especially Bristol, prospered.

Foreign merchants were forbidden to remain in Cork for any length of time, they could not acquire a wine tavern and were forbidden to purchase corn, leather or wool except with the permission of, and from, the citizens. The charter also provided for the establishment of Guilds, in the same manner as the Burgesses of

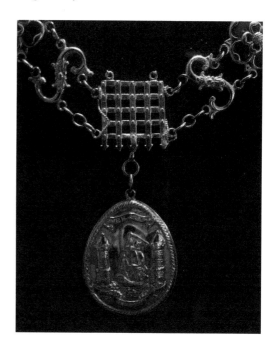

Section of the Lord Mayor of Cork's chain. The chain dates to 1787. (Kieran McCarthy)

Bristol. In 1326, there was a significant commercial development in the city when an Act of Parliament declared it to be a Staple Town, meaning that markets of hides, wool and fell wool (sheepskin) could be held only in Cork, conferring on the city a virtual monopoly in the trade.

The first official references to mercantile groupings within the walled town of Cork appear in a 1608 charter of James I: the positions of Mayor, Sheriff, Coroner and Escheator and Commonalty were established, along with the Society of Merchants of the Staple.

The Strength of Cork, 1602

George Carew, president of the Munster Plantation, on his plan of Cork *c.* 1602 shows the town wall of Cork encompassing an oval-shaped settlement on a swamp. His emphasis is on showing off the infrastructure. He depicts the town as a spacious, strong and prominent settlement, complete with the protection of drawbridges and the eastern portcullis gate called Watergate. The raising up of such structures must have been and noisy and creaky, which must have irked the visitors to the town.

The walled defences, 1,500 metres in circumference, were to provide security for its inhabitants up to 1690. On the map, the buttress walls and its drawn lines that rise from the marshy ground give the structure a striking strength and depth of foundation. The hardness and indestructibility of the stone has a noble look to it

and fitted Carew's idea and vision of a colonised landscape. Much of the town wall survives beneath the modern street surface and in some places has been incorporated into existing buildings. Carew presents a wall on his map almost mass concrete looking; he doesn't show the reality of the use of multiple stones in its construction, as seen in the wall on display in Bishop Lucey Park. The wall comprised two stone types: limestone and sandstone. The engineering involved in its construction was substantial. The citizens must have had problems in laying foundations into the swamp. Their timber scaffolding must have collapsed at times. The courses of the stone must have collapsed. It was a jigsaw puzzle in its construction.

Elements of the ground plan of the walled town survive. If one starts on the corner of the Grand Parade and the South Mall, on the city library side, the walls of the medieval town would have extended the full length of the Grand Parade, along Cornmarket Street, onto the Coal Quay, up Kyrl's Quay to the North Gate Bridge. From here they would have extended up Bachelor's Quay as far as Grattan Street, then turning southwards, the walls would have followed the full length of present-day Grattan Street as far as present-day Clarke's Bridge. The walls then followed the course of the River Lee back to the starting point.

Some of the wealthier merchants formed the corporation and lived in tower houses or large two- to three-storey castle-like structures. They were as important

A description of the Cittie of Cork Plan of Cork, c. 1602, by George Carew. (Cork City Library)

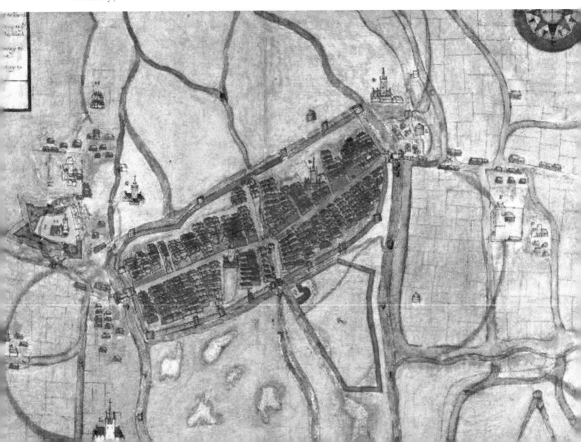

as the infrastructure and many were the key agents of governance for centuries. These families included the Roches, Skiddys, Galways, Coppingers, Meades, Goulds, Tirrys, Sarfields, and the Morroghs. Their names were all involved in the running of the town from its inception in the late 1100s to the seventeenth century. They also controlled large portions of Cork's trade and rented out numerous plots of land to other citizens – Irish natives and English colonialists.

The Prestige of Cork, 1759

By the time of John Rocque's map of Cork in 1759, the walls of Cork were just a memory – the medieval plan was now a small part in something larger, larger in terms of population from 20,000 to 73,000, plus in terms of a new townscape. Rocque in 1759 shows that new bridges, streets, quays, residences and warehouses had been built to intertwine with the natural riverine and swampy landscape.

John Rocque (*c.* 1705–62) was a cartographer and engraver of European repute. He could count among his achievements maps of London, Paris, Berlin and Rome. In Britain, his many projects included plans of great gardens, several county and provincial city maps and a great, highly innovative, survey of London which resulted in a sixteen-sheet map of London and its immediate hinterland (1746), and an immense twenty-four-sheet map of the city itself (also 1746), laid out at a very large scale close to 200 feet to an inch.

John Rocque's Irish work between 1754 and 1760 includes a remarkable series of *c.* 170 manuscript estate maps for the Earl of Kildare, and a range of commercially driven projects that resulted in finely engraved and printed surveys of the cities of Dublin, Cork and Kilkenny, a town map of Thurles, county maps of Dublin and Armagh, and a general map (derived mainly from existing sources) of Ireland.

The 1759 Cork map is impressive in its detail. John Rocque aimed to depict more than just physical infrastructure. His maps also encompassed a series of ideas that would mean much to a multitude of audiences, from local to international. In his Cork map is the interplay between past and present, between material and symbolic worlds. This map was commissioned within the prevailing political context and was used to create a colonial landscape of control and order – controlling images of people and their past. Historical information of the map's commissioner has been lost to time.

In terms of the cartography itself, John Rocque reveals a properly arranged landscape devoid of medieval twists and tightness of space, entwined with new widened spaces. He reflected the importance of uniformity – a reference to classical lines symbolic of prosperity, humanity and prestige of the whole community.

John Rocque's drawn cluster of ships marks a reflection of a world of industry, capitalism, and social mobility. Across his map he marks in buildings of administration, commerce, welfare, religion and culture. He even shows the edge of the city, the spaces

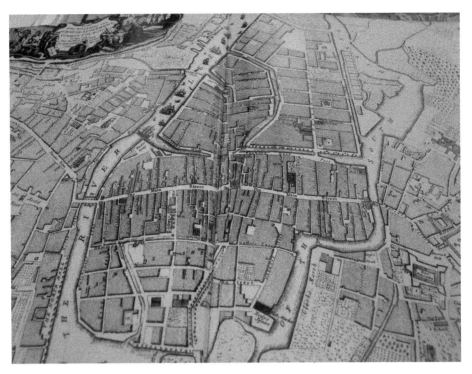

John Rocque's map of Cork, 1750. (Cork City Library)

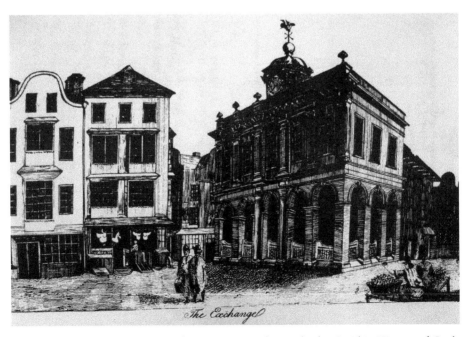

The Exchange, Cork's central trade centre, 1750, from Charles Smith's *History of Cork*. (Cork City Library)

of social dislocation – rising slum areas, which in time grew to be one of the city's darker corners of human misery and which were not cleared till the 1920s.

The other significant features that emerge in view on this map are the canals and the links to changing technologies, reclamation, bridge construction, riverbank consolidation, and the creation of quays – all connected to new emerging urban civilisation within a network of canals, reminiscent of Venice, Amsterdam, Copenhagen. Cork's central canal lined the centre of the newly reclaimed area with admirable buildings on both sides bearing a special relationship to the water.

The Swell of the Tide, 1850

George Mounsey Wheatley Atkinson, who lived from 1800 to 1884, was a locally noted maritime artist. He was untrained as an artist but was a seaman, and his understanding of the complicated rigging of tall ships is apparent in all his works. A number of his paintings, as well as those of the Atkinson family, are on display at the Crawford Art Gallery, Cork City. Born in Cobh of English parents, he went to sea as a youth working as a ship's carpenter. He later became Government Surveyor of Shipping and Emigration at Queenstown and was known locally as Captain Atkinson. He first signed paintings in 1841 and exhibited maritime paintings at the RHA from 1842 showing many views of the entrance to Cork Harbour, Cobh, river views, the River Lee and scenes of ships. His painting *Visit of Queen Victoria and Prince Albert to Queenstown in 1849* was lithographed and published by W. Scraggs of Cork, and his volume *Sketches of Norway* was lithographed by his son and published by Guy and Company of Cork.

George's work *Boat Entering Cork Harbour* from *c.* 1850 visibly shows the swell of the tide and the river but also the sailing ships and the steam ships. The city's Custom House, the Cork Steam Packet Office, and the then relatively new St Patrick's Church are very prominent structures shown.

The Custom House was designed by William Hargrave in 1881 and built at Custom House Street between the north and south channels of the River Lee. At the time its main work dealt with inland revenue. In 1904 the Cork Harbour Commissioners took over the building on a 999-year lease. In 1906 a magnificently ornate boardroom, designed by William Price, the then Harbour Engineer, was added to the building. Equally impressive is the Committee Room, a dark wood-panelled room with pale cream and gold wallpaper and a delicately patterned ceiling. The Boardroom and Committee Room house a fine collection of maritime artwork owned by the Port of Cork Company.

Around 1824, St George Steam Packet Company erected a premises known as the packet office on Penrose Quay, which they surmounted with a sculpted piece of Saint George slaying a dragon. The first two steamers employed by the St George Company to and from Cork were the *Lee* and *Severn*, both built in Liverpool in 1825 (*Lee* for Liverpool trade originally and the *Severn* for Bristol trade).

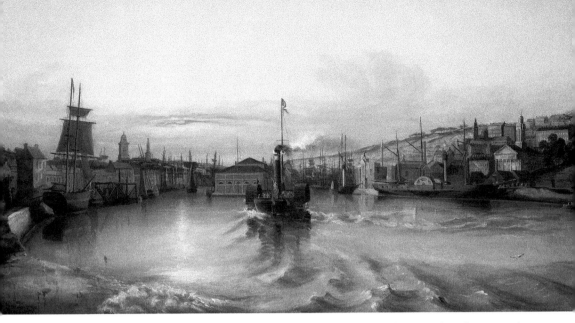

George Mounsey Wheatley Atkinson, *Paddle Steamer Entering the Port of Cork*, 1842, oil on canvas, 61 x 100 cm. (Collection Crawford Art Gallery, Cork)

As the reputation of the Cork site was established, the St George Company extended its operations with marvellous rapidity, until steamers were to be found in almost every port in the United Kingdom – in chief ports of Holland, Denmark and Russia. However, St George Company was not content with just being connected to an English company. So investor Mr Ebenezer Pike of Bessborough, Blackrock, County Cork, convened a meeting of the shareholders, which was held at Cork on 17 February 1843. Before the meeting, Mr Pike had forwarded to each shareholder a copy of a circular in which he proposed to form a separate company from the English business. In October 1843, the title St George was dropped and the title City of Cork Steamship Company was established. The name was later shortened to the Cork Steamship Company.

The Essence of Water Lane

Ireland: Its Scenery and Character (1840) is a travelogue of sorts by Samuel Carter Hall (1800–89) and his wife Anna Maria (1800–81). Samuel was a well-known journalist and editor of *The Art Journal*. Anna Maria was a novelist and playwright. It is a three-volume guide to Ireland between 1841 and 1843. Each chapter is dedicated to a different county. Volume I examines the counties of Cork, Kerry, Waterford, Limerick and Carlow.

Many illustrations, including ink drawings, sketches, paintings and maps, are included in the guide. Within the Cork section of Volume I there are many nods to the resilience of community life in Cork, which still strongly prevails. The Cork section comprises a sketch of Water Lane in Blackpool, which was utilised by

local historians writing about nineteenth-century Cork and life for impoverished communities. The Halls remark upon the image and its peculiar character:

> The most remarkable is the painter James Barry of the house in which he was born, Mr Crofton Croker has supplied us with a sketch, which we copy, not merely because of its interest in association with the memory of the eccentric artist, but as affording a correct idea of the peculiar character of the suburb of an Irish town. The house is in Water Lane, in the northern or 'Blackpool', suburb, and is marked by two women at the door.

The reference to Thomas Crofton Croker carries the image back to his celebratory research on Irish traditions and community stories in the early nineteenth century. Born in Cork in 1798, Thomas had considerable talent as an artist. From the age of fourteen he made several excursions in the south of Ireland, sketching the character of people. He went to London as a clerk in the Admiralty for thirty years. His books include *Researches in the South of Ireland* (1824) and *Fairy Legends and Traditions of the South of Ireland* (1825).

The reference to James Barry is also of significance. Born in Cork in 1741, his father had been a builder, and, for a time, a coasting trader between the two countries of England and Ireland. To this business of trader James was destined, and he actually made several voyages as a boy. However, following his own inclinations led James towards drawing and study. His early paintings attracted

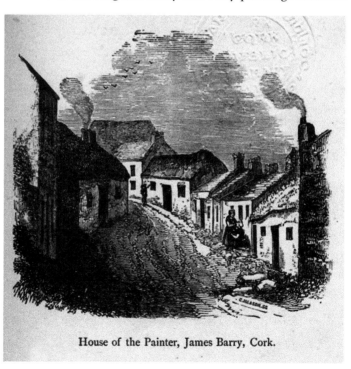

Water Lane, Blackpool in *Ireland: Its Scenery and Character* (1840) by Samuel Carter Hall (1800–89) and his wife, Anna Maria (1800–81).

House of the Painter, James Barry, Cork.

the patronage of Edmund Barry, who pushed for his work to be put on display in Dublin and London. In the latter part of 1765 James was enabled to study and paint abroad. He went first to Paris, then to Rome (where he remained upwards of three years), from Rome to Florence and Bologna, and thence home through Venice.

In 1774, a proposal was made through Valentine Green to Sir Joshua Reynolds, West, Cipriani, for Barry and other artists to ornament the Great Room of the Society for the Encouragement of Arts, Manufactures and Commerce (Royal Society of Arts) in London's Adelphi, with historical and allegorical paintings. The series of six paintings was known as *The Progress of Human Knowledge and Culture*. Soon after his return from the Continent, James Barry was chosen as a member of the Royal Academy.

The reality of his home in Blackpool was quite different from the halls of Westminster. In the northern districts of the city were the most crowded and populous streets. Wretched houses, divided into separate tenements, accommodated a large number of people – upwards of four people in small rooms. The distress amongst the people in Blackpool was terrible and many families were on the verge of starvation, ashamed to make public their abject poverty. There was an enormous want of cleanliness and proper ventilation. Strong recommendations came right into the early twentieth century that such houses should be altogether closed up. In time many of the impoverished were moved to more spacious housing in the suburbs.

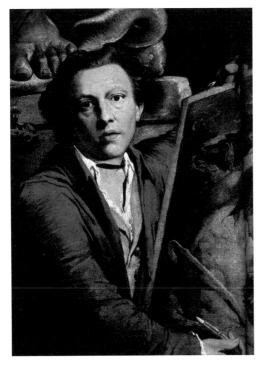

Self-portrait of James Barry, *c.* 1780. (Cork City Library)

Ornaments of a City

The Dials of Public Time – Mangan's Clock

After lengthy public pressure for a public clock, Cork Corporation installed the four-faced clock on St Anne's Church, Shandon, in 1847. It almost immediately gained the nickname of four-faced liar because of a tendency for the east and west faces to run ahead of the other sides in the upward journey from the half hour to the hour. The clock and its faces were installed by James Mangan and his son, Richard. The Mangans received £250 for the contract and were paid £13 per year for winding the clock in the early years. At the time of its construction the clock at Shandon was reckoned to be one of, if not the biggest in Europe.

The Mangan company was founded in Cork in 1817 by James Mangan, clockmaker (who was born in Caroline Street, Cork, in 1793). John Francis Maguire MP, in his book *The Industrial Movement of Ireland* (1853), noted the reputation of the Mangan family and of the growing need for telling the time to a public audience especially in an age where not everyone had a watch:

> Within the last twenty years, the attention of various public bodies in Cork has been directed to the better regulation of time and the liberality of one of those bodies has afforded a fitting field for the display of the genius and mechanical skill of a local tradesman—Mr. James Mangan whose work has been pronounced, by the best judges, to be equal to any in the world, and whose monster clock in the Church of St. Ann's Shandon is one of the largest, if not the largest, in Europe. His clock on the Com Market—in which, with the adjoining buildings, the National Exhibition was held—has five dials, one inside the buildings, and one on each of the four exterior sides of the turret. But his grand work is the Shandon Clock created by order of the Corporation.

On the Clocks of St Anne's Church, Shandon, John Maguire notes:

> The dials on St Anne's are four in number, and are 15 feet 8 inches in diameter. The four sets of hands weigh 5 hundredweight. The frame of the clock is

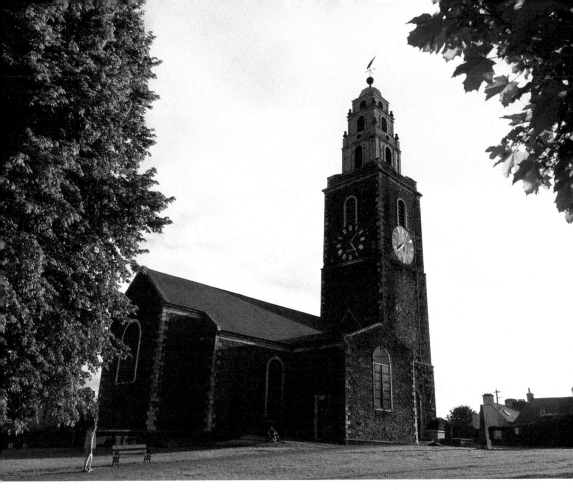

Above: St Anne's Church, Shandon, May 2020. (Kieran McCarthy)

Below left: Clock face on St Anne's Church, Shandon, May 2020. (Kieran McCarthy)

Below right: Close-up of clock face on St Anne's Church, Shandon, May 2020. (Kieran McCarthy)

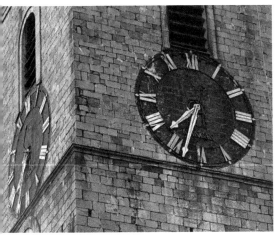

11 feet 6 inches long, 4 feet wide, and 5 feet high, and weighs, with its machinery, 2.5 tons. The striking hammer weighs a 100 lbs and falls through a space of 12 inches – which shows the great power of the mechanical force exerted in the striking part of the clock – and the chime hammers, four in number, weigh 26 pounds each. The pendulum is 14 feet long, the ball weighing 3 hundredweight.

The other Mangan clock of repute in Cork City is a pillar clock erected in early 1891 on St Patrick's Street, opposite St Patrick's Bridge. It is a large double-faced drum perched upon a wrought-iron pillar 23 feet high. On the premises of the Mangan business was turret clock machinery which, by means of a rod underneath the pathway, and rising through the centre of its supporting pillar to the drum, worked the hands. By this system the clock was easily wound and regulated.

A Landmark of Good Temperance

Soon after the death of famous temperance campaigner Fr Theobald Mathew in December 1856, a committee of citizens was formed for the purpose of erecting a suitable memorial in Cork City. The commission was entrusted to the famous sculptor John Hogan, who in his early days was raised in Cove Street and had been acquainted with Fr Mathew. Hogan died in 1858 and on his death a meeting of the committee was called. It was reported that they had on hand the sum of £900, and on the motion of John Francis Maguire MP, it was agreed to give £100 to the Hogan family in recognition of what Hogan had already done on the contract. The sculptor's eldest son, John Valentine, endeavoured to carry out his father's work and in June 1858 another meeting of the community was held at the Athenaeum to inspect a model of a statue he brought to Cork.

However, the commission was handed over to John Henry Foley. He was the second son of Jesse Foley, a native of Winchester, who had settled in Dublin. When John had reached the age of thirteen, he decided to follow his eldest brother in the profession of sculptor. He entered the school of the Royal Dublin Society where he soon distinguished himself by winning many prizes for drawing and modelling. In 1823 he won the major award of that school. This success induced him to follow his brother to London where he joined the schools of the Royal Academy. Within a short time, he submitted a study entitled 'The death of Abel', which won him a ten-year scholarship to that establishment. Foley's next noteworthy achievement was exhibiting in the Royal Academy in 1839, and ten years later he was elected a full member carrying the letters RA after his name. At forty years of age the sculptor had achieved the highest honours. Foley's output was prodigious, and his works are to be found in India, the USA, Sri Lanka, and Scotland, as well as Ireland. His subjects were deemed classical and imaginative, and included equestrian statues, monuments and portrait busts. Two years after the unveiling of the Fr Mathew statue, his Daniel O'Connell monument in Dublin was unveiled.

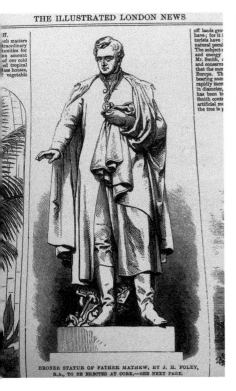

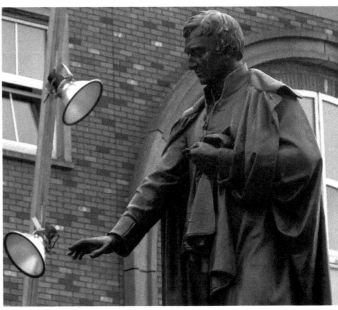

Above: Fr Mathew Statue, June 2020. (Kieran McCarthy)

Left: Fr Mathew Statue, as depicted in the *Illustrated London News*, 26 December 1863, p.665.

The Fr Mathew statue was unveiled on 10 October 1864 amidst a concourse of thousands of people and public celebration. Both the *Cork Constitution* and *Cork Examiner* the following day carried lengthy and vivid accounts of the pomp and ceremony. The statue had been cast in the bronze foundry of Mr Prince, Union Street, Southwark, London. As well as obtaining a remarkable likeness of Fr Mathew, the sculptor posed the figure as a representation of him in the act of blessing those who had just taken the temperance/abstinence from alcohol pledge. On the statue's arrival in Cork, it was placed on the stone pedestal which had been designed by a local architect William Atkins.

The Heroic Example – Cork's National Monument

The original plan of Cork's Young Ireland was to unveil a National Monument for Cork in 1898 to mark the centenary of the 1798 United Irishmen rising. For two years a foundation stone lay at a city centre site, ready for the commencement of structure, but as the years passed by it seemed less and less hopeful that the monument would be completed.

Four years later the project was back on track. Designs for the monument were invited, from which Mr D. J. Coakley, architect, was deemed the most suitable. A contract was laid in place with Mr Ellis Coakley for a sum of £2,000. In 1902,

collectors of the Young Ireland Society were to be seen Sunday after Sunday at church doors and in the streets gathering in the coppers and pence of the workingmen and artisans of the city. Four years of collections of this kind left the committee with a very creditable fund of nearly £700. In places such as Brooklyn, St Louis, and San Francisco prominent Corkmen pledged funding so that nearly £400 was added to the pot.

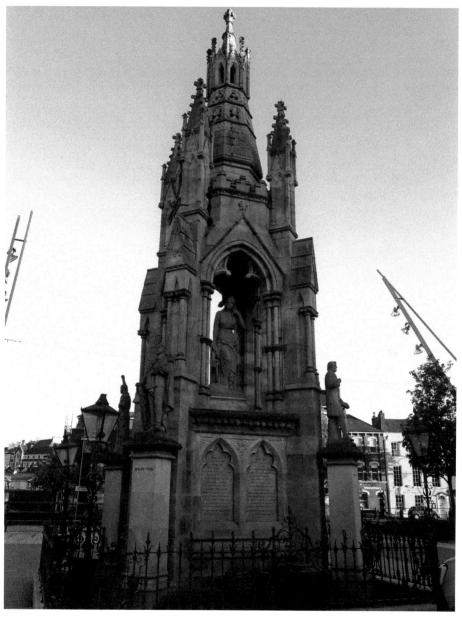

National Monument, Grand Parade, Cork, June 2020. (Kieran McCarthy)

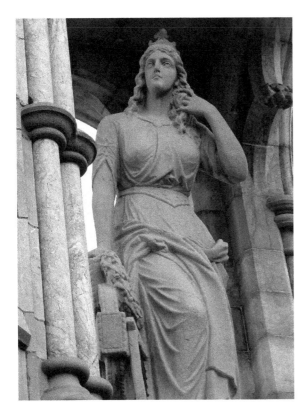

Maid of Erin, National
Monument, June 2020.
(Kieran McCarthy)

By March 1906, almost every town and village in the county had contributed, and it was only fair to say that in this respect Passage gave first, having contributed £50, while Cove gave £54 and Charleville £43. Not a single penny of the money collected was spent outside the country. They had got a cheque from America for £150, with a promise of a further cheque in the course of subsequent weeks. They had secured the services of their esteemed president, Fr Kavanagh, to perform the unveiling ceremony, and they had also secured the services of Capuchin Fr Thomas O'Connor, to deliver an oration 'On the Day We Celebrate'.

On 17 March 1906, thousands of citizens turned out to see the official unveiling. Fr Kavanagh performed the ceremony amidst a scene of enormous enthusiasm with a band playing 'Who Fears to Speak of '98'.

The monument was designed by well-known architect D. J. Coakley, who designed the facade of nearby Holy Trinity Church. Indeed, the neo-Gothic design of the monument bears a striking resemblance to the front of the church. At the base there are four steps, with a boldly moulded plinth. Flanking the four buttresses are square pedestals with moulded bases and caps. On these are placed statues of Wolfe Tone, Michael Dwyer, Thomas Davis and O'Neil Crowley. The central statue under the canopy is Erin, and is around 8 feet high. The height of the monument is 48 feet, and its breadth at the base is 15 feet. John Francis Davis, a Kilkenny man with a studio in Dublin, sculpted the statues.

The Pasts of the Past – The First World War Memorial

Just metres from Cork's National Monument lies the city's First World War memorial. The tragedies and complexities of Cork history are laid bare as their respective stories jar with each other – one marking fallen comrades in rebellions against the British Empire and the other marking fallen comrades who fought against the British. Such conflicting narratives arise regularly in Cork's history.

The figure of 49,435 war dead is the one adorned on the Irish National War Memorial at Islandbridge in Dublin based on the Irish Memorial Roll drawn up after the war. Unfortunately, the rolls are full of discrepancies. They detail all those who died in Irish regiments, but many of those soldiers were not Irish, and many Irish who died in non-Irish regiments are not recorded.

The Irish Memorial Roll lists 4,918 dead from Dublin, but First World War scholar Tom Burnell says the true figure is 8,479. Similarly, the official figure for Cork is 2,244, but he puts it at 4,338. Crucial work in the book *A Great Sacrifice* (2010, edited by Gerry White and Brendan O'Shea) reveals an underestimation of total figures. When the war ended in November 1918 the Royal Munster Fusiliers had suffered around 2,800 killed with thousands more wounded, and the regiment had been reduced to its two regular battalions, a reserve battalion and two garrison battalions.

Following the successful erection of a Celtic Cross by Cork Independent Ex-Servicemen in July 1924, a plan was put in place to remember fallen comrades in Cork City. On 27 October 1924 at a meeting of Cork Corporation, the question of the erection of a monument to the memory of the Cork soldiers who fell in the First World War came under consideration, with the view of having recommendation made to the council on the matter. An application was read from the Irish branch of the Great War Memorial Committee, asking for permission to erect a monument on Parnell Place (facing Parnell Bridge) or the park, at the Grand Parade end of the South Mall. The debate favoured the centre of the small park on the South Mall but there were divisive perspectives with some members condemning it as a monument to British imperialism and others supporting it as monument to the fight for small nations and their sovereignty. After a margin of one vote permission was granted to site the monument in the small park.

On 17 March 1925 the memorial dedicated to their fallen First World War comrades was unveiled by Cork Independent Ex-Servicemen. Members of the British Legion joined in the ceremony, as did large numbers of soldiers' relatives and thousands of the general public. Relatives of the fallen men and public representatives were accommodated inside the railings of the little park in which the memorial stands.

The unveiling of the memorial was performed by General Harrison, a former commanding officer of the Royal Munster Fusiliers' Depot. He drew the Union Jack aside and revealed the monument with its soldier standing with bowed head and arms reversed. Its inscription reads: 'Lest We Forget'. In his address, the

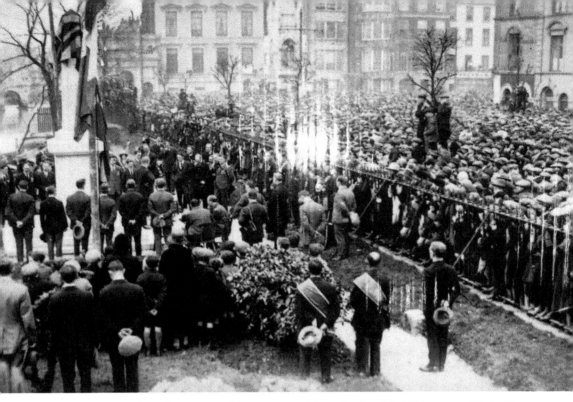

Above: Unveiling the First World War memorial on the South Mall in 1925. (Cork City Library)

Below: Centenary Remembrance ceremony of Armistice Day at the First World War memorial, South Mall, with former Lord Mayor Cllr Mick Finn, 11 November 2018. (Kieran McCarthy)

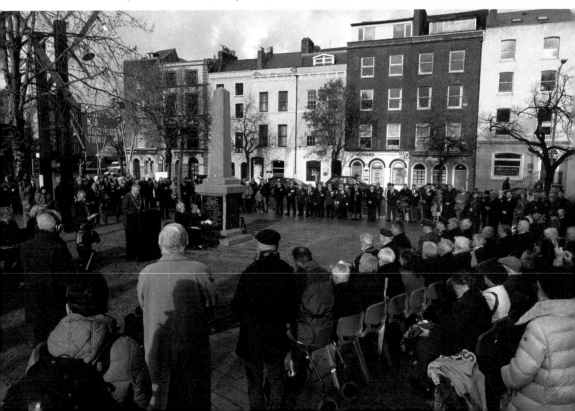

First World War Memorial, Cork,
present day. (Kieran McCarthy)

General said he would avail of the occasion to ask the government of the country
to see its way to help the dear ones of those men who had fallen, and also to help
men who would have given their lives if they were asked to, and many of whom
were now poor and hungry. They deserved any help that the government could
give them, and he felt sure that such help would be forthcoming.

A Budding Lily – Cork Remembers 1916

On 23 June 2016, an impressive new monument commemorating members of the
Cork City Battalion of Irish Volunteers, who were ready to fight in the 1916 Easter
Rising, was unveiled by Lord Mayor Cllr Chris O'Leary. The monument, at the
South Mall's junction with Parnell Bridge, was commissioned and donated to
the city by the family of Seán Murphy, battalion vice commandant and brigade
quartermaster. Sean Murphy was part of the campaign which took place on Easter
Sunday morning, 23 April 1916. Terence was a part of the group of 163 Volunteers
from the Cork City Battalion who, together with others from Cobh and
Dungourney, paraded under arms outside of the Volunteer Hall and prepared to
take part in the manoeuvres that were a cover for the Rising planned to establish
an independent Irish Republic. After an address by Brigade Commandant Tomás
MacCurtain, they marched off to Capwell railway station to board a train for
Crookstown. However, just as they were departing, an order arrived from Dublin

cancelling the operation. This was the latest in a series of conflicting orders that had been received by MacCurtain during the previous week. Tomás felt he had no choice but to stand his men down and order them to return home.

Later negotiations between both the British army and the Volunteers, and mediated by the Lord Mayor of Cork, Cllr Thomas C. Butterfield, and Assistant Bishop Cohalan, eventually led to the surrender of weapons. Tomás MacCurtain and Terence MacSwiney were arrested and detained in Frongoch internment camp in Wales along with those who fought in Dublin.

Cork sculptor Mick Wilkins completed the work to coincide with the year-long centenary celebrations of the Rising, before Seán Murphy's family gifted it to Cork City Council. The monument comprises two white forms, representing the two channels of the River Lee which rise to create the form of a budding lily – the recognised symbol of the Rising. However, the forms are deliberately abstract to allow people interpret them as either flames, representing the upheaval of the time which included the burning of Cork City, or two hands coming together in prayer. Its base contains a plaque replicating a service certificate issued in 1948 to each member of the Cork City Battalion. The plaque lists the names of those in A, B, C, and D Companies and members of Fianna Éireann.

Unveiling a commemoration plaque on the Volunteer Hall, Sheares Street, 28 March 2016. (Kieran McCarthy)

Above: Unveiling of
1916 Monument, South Mall,
23 June 2016. (Kieran McCarthy)

Right: 1916 Monument, South Mall.
(Kieran McCarthy)

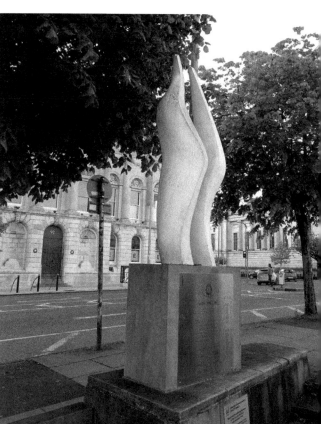

Arts and Crafts

Inscriptions of the City – A Coat of Arms

Always creative and always beautiful is one way to sum up the various Cork coat of arms images: from etchings on old maps to the Lord Mayor's chain to appearing on City Hall flag motifs, to Waterworks, to the Port of Cork boardroom, to the City Library, Fire Engines to Cork GAA jerseys. It is unknown when the coat of arms was first used – there were a number of earlier versions. Richard Sainthill refers, in *An Olla Podrida* Vol. 2, to the Cork City seal attached to a document dated 15 October 1498. On one side of the seal were the three lions of England only, which evidenced that it had been engraved previous to the reign of Edward III, when the fleurs-de-lis were added. On the other side of the seal is a castle with two towers – a man in one with a bow, and in the other a man in a pleading attitude, blowing a trumpet. A bridge connects the two towers, beyond which a ship is seen. It may be of interest that the Bristol coat of arms shows a ship beside a castle with two towers and a flag flying from each tower.

An arms with two towers and ship appears on the side of Munster Plantation president George Carew's 1601 map of Cork. It is reputed that the towers are a reference to Watergate, which comprised a large portcullis gate that opened to allow ships into a small, unnamed quay located within the walled town. On either side of this gate, two large mural towers, known as King's Castle and Queen's Castle, controlled its mechanics. Little evidence remains of the gate, but on the basis that it had to allow access to ships with full masts, Watergate possibly divided in two and opened like a door, rather than being wound up and down by means of a stout chain on a pulley system. In 1996, when new sewage pipes were being laid on Castle Street, archaeologists found two portions of rubble that indicated the site of the rectangular foundations of Queen's Castle. A further section was discovered in 1997. During these excavations, sections of the medieval quay wall were also recovered on Castle Street.

A new mayor's gold chain was placed on the shoulders of Mayor of Cork Samuel Rowland in 1787. It was voted on by the court of D'Oyer Hundred – or the city's assembly of freemen. The sum of £500 was given as a bond by the then mayor

who needed to be paid back, and the money sent on to the London goldsmith. The highlighted medallion has the coat of arms and the Latin inscription *Statio Bene Fida Carinis*, which means a safe harbour for ships. The inscription is a corruption from the second book of the *Aeneid*, line twenty-three, with 'bene' substituted for Virgil's 'male'.

In 1825 a pen and ink sketch by nineteenth-century local artist Daniel Maclise of the Cork arms from a stone from the old Custom House, North Main Street, shows a ship between two towers or castles with a sailor, in Elizabethan period dress, and a bird on the rigging. The sketch can be seen in the Cork Public Museum.

The arms of Cork City were officially registered by the Chief Herald on 23 August 1949 and are described as follows:

Órdha ar thonntracha mara long trí-chrann fá lántseol dualdaite idir dhá thúr dhearg ar charraigeacha dualdaite ar gach túr bratach airgid maisithe le sailtír dheirg leis an Rosc 'Statio Bene Fide Carinis'.

'Or, on waves of the sea a ship three masts in full sail proper between two towers gules upon rocks also proper each tower surmounted by a flag argent charged with a saltire of the third with the Motto 'Statio Bene Fida Carinis'.

Drawing of post-medieval stone piece of Cork coat of arms attributed to Daniel Maclise, 1825. (Courtesy of Cork Public Museum)

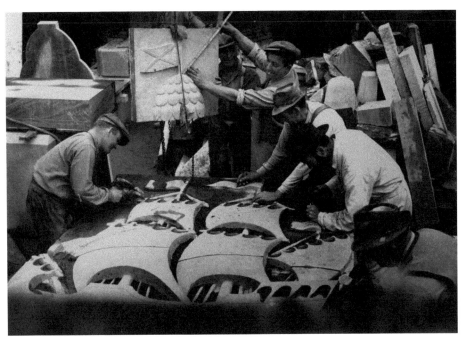

Nearing completion, 22 September 1956, two sections of the 12-foot-high and 24-foot-long Cork coat of arms of Irish limestone, quarried from near St Mary's Church, Knocknagoshel, which was to replace the old one of the lion and unicorn emblem erected on the Cork Harbour Commissioners building during the British regime, is seen here being prepared in the yard of Messrs Tom McCarthy and Son, Cork. Working on it was well-known Cork sculptor Mr Marshall C. Hutson, with Messrs Alfred McCarthy, Tadgh McCarthy, John McCarthy, Denis Casey, and Jerry McCarthy. (Cork City Library)

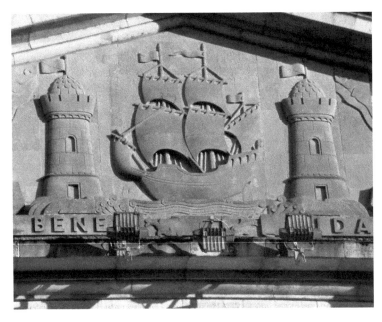

Coat of arms on Port of Cork or former Cork Harbour Commissioners building, June 2020. (Kieran McCarthy)

Nine years later, after the official registration in 1957, one of the most striking pieces was installed above the entrance to the Cork Harbour Commissioners. The Cork Harbour Board, with a certain amount of ceremony, inaugurated a new symbol in front of their offices to take the place of an old one which was supposed to be a relic of British domination, usually described as the royal coat of arms. On 8 April 1957, Alderman Sean Casey, TD, Lord Mayor of Cork, unveiled the Cork coat of arms over the entrance to the office of the Cork Harbour Board at Custom House Quay. In Kilkenny limestone, the heraldic design depicts the ancient arms of the city. In the speeches tribute was made to Mr Marshal Hutson, the Cork sculptor who designed the coat of arms, and to Messrs Thomas McCarthy and Sons, Copley Street, Cork, monumental sculptors who executed the work. Its erection marked the conclusion of a total reconstruction of the South Jetties, and the completion of the first two stages of the long river wall on the northern side.

The Marvels of Architecture – The Place of SS Peter and Paul's Church

There is much beauty in SS Peter's and Paul's Church. With designs by Edward Welby Pugin, the architect created a structure full of interesting details. From the use of marble in pillars to the wooden carvings of angels and the confessional boxes, many details are quite striking.

Within the body of the church there are columns either side of the nave. There are five of these on either side forming eight arches. The bases of all these columns are formed of black marble, obtained at the mouth of the Shannon at Foynes. Over these the plinths and columns rise in polished red marble obtained in County Cork, from the locality of Churchtown, and up to 1866 was almost entirely used for mending roads. After being used in SS Peter and Paul's Church, it was deemed a most beautiful and valuable marble by architects and was exported by hundreds of tons to England for the adornment of public buildings in various towns there. The capitals or top features resting on these columns are carved in the manner of fruit and flowers and are marked in various ways.

The other pillars in the church, round the side altars, and under the choir, are also carved: round the Sanctuary in white Sicilian marble and Galway green, and under the choir in red marble, quarried in Little Island, County Cork.

The three altars, the grand and two side altars, are objects of great beauty and interest. It was after a number of years that the grand altar was supplied. This was due to deficiency of resources, but according to the *Cork Daily Reporter*, the temporary altar in 1866 was a carefully decorated and handsomely constructed piece of workmanship. It was decorated in pure white and gold, representing purity and charity, and even with the surrounding grandeur of the church, looked fitting and suitable. It was proposed in 1866 that when the permanent grand altar

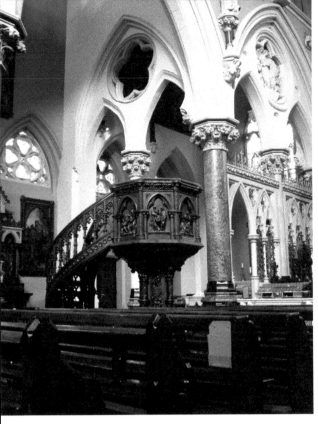

Left: Carved pulpit in SS Peter's and Paul's Church, June 2020. (Kieran McCarthy)

Below: Interior of SS Peter's and Paul's Church, June 2020. (Kieran McCarthy)

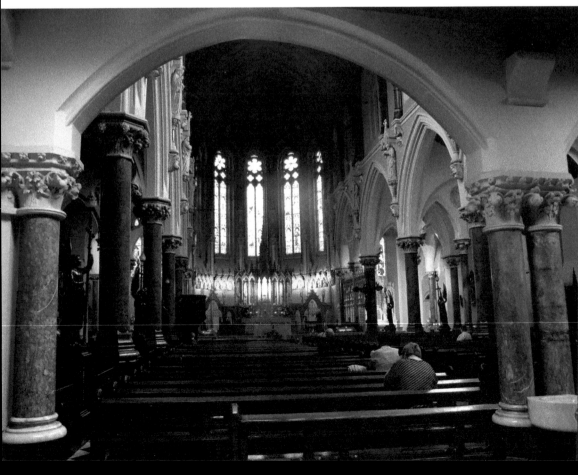

was supplied it would be built only of the purest white statuary Carrara marble, which would cost from £1,500 to £2,000.

The dome of the apse or the altar area, by which it is surmounted, is a marvel of art. It is pointed and decorated, one of pure symbolism and which yet never departs from any rule of artistic beauty: its blue ground indicates the sky; its golden decorations consisting chiefly of the various emblematical figures of the keys and sword of SS Peter and Paul; and pelican, the cherubim and seraphim; and the golden specks to represent the stars moving is deemed a rare delicacy of execution.

Beautiful carved statues of the twelve Apostles are around the church, resting on corbels, consisting of angelic figures surmounting the pillars and between the archways on the opposite sides of the nave or the central aisle. Each of these is a gift from some generous Catholic family in the city, and in the arms of the angel supporting each corbel is a shield containing the arms of the respective donor of each, painted in colours. The benches of the church are of pine, with open backs, moulded tops and ornate rails and ends.

A *River of Life* – The Mosaics of the Honan Chapel

The opening event of the Honan Chapel, on 5 November 1916, was marked with great speeches and insights into the work involved in its construction from the funders to the craftsmen. The Honan Chapel is a national icon of Irish craftsmanship. The chapel represented a vision – the contemporary political interest in promoting the culture of Ireland and the search for an Irish identity by several leading political figures. The erection of the chapel was entrusted to the well-known building firm of Messrs John Sisk and Son. The work was carried out under the superintendence of Mr Peter O'Flynn as Clerk of Works. John Sisk set up his construction business in 1859 and by the early twentieth century had an impressive record of work around the province of Munster, building schools, hotels, banks and thirty churches.

Reviews of the building by the *Cork Examiner* on 23 October and 6 November 1916 point to the beauty of the interior and that it may strike the visitor as very simple but to execute the ornamentation 'required painstaking care and skill and possession of the artistic faculty as well'. The Honan Chapel interior adopted the most decorative features in Cormac's famous chapel at Cashel in the arcading. The carving was carried out by workmen under Henry Emery, an architectural sculptor and decorator. Liverpool-born Henry Emery was active across the country from the 1870s until the 1930s and had his practice in Dublin. He was apprenticed initially to the stone and marble works of Alfred P. Sharp of No. 17 Great Brunswick Street, Dublin. Sharp was also a builder. Around 1877 Henry Emery was placed in charge of the stone and wood carving side of the business. He was taken into partnership by Sharp in the late 1890s. The series of stained-glass windows of the Munster

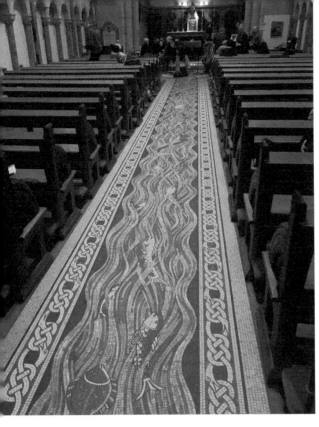

Left: *River of Life* mosaic in Honan Chapel, June 2020. (Kieran McCarthy)

Below: Section of *River of Life* mosaic in Honan Chapel, June 2020. (Kieran McCarthy)

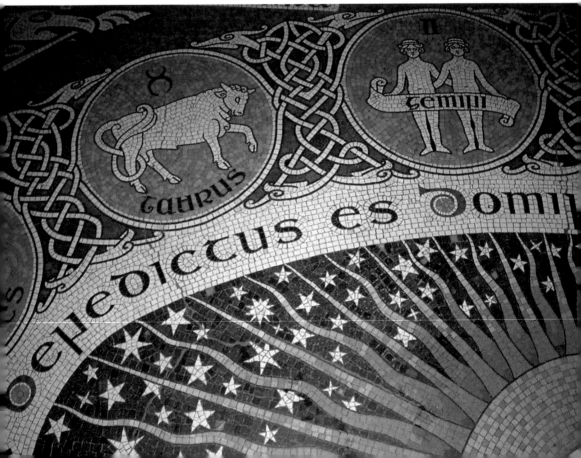

saints from the eminent studios of Harry Clarke and Sarah Purser begin on the north wall of the nave near the chancel with the window in honour of St Finbarr.

The *River of Life* has to be seen to be appreciated. The mosaic depicts a great beast who lifts his head and from his mouth flows the mighty river. In its waters are many strange monsters, all journeying towards the altar. In the front of the Sanctuary the waters separate and a whimsical beast, half serpent, half whale, relaxes upon the surface of the central stream, while in the waters to the right and left various land animals drink and are nourished.

On either side of the river animals from distant climates blend with the ox, sheep and squirrel, while exotic and very colourful birds fly in and out among many kinds of forest. Within the Sanctuary different panels depict the sun and moon, stars shooting across the sky, wind, rain, ice and snow, fire and water, mountain and plain, flowers and fruit, and all things created by God. Celtic interlacements form a border for the whole. The wonderful design was inspired by the Canticle of the Three Children in the Fiery Furnace from the Book of Daniel (III, 57–58).

The Gibson Intervention – Funds for the Crawford Art Gallery

There are many curios in the Crawford Art Gallery – its exquisite set of Antonio Canova sculptures and paintings within its collections make for great viewing and scholarly output. The gallery opened in 1885, built with the generous financial support of William Horatio Crawford. The next generous sponsor has for the most part fallen out of Cork memory and that is the name of Joseph Stafford Gibson, who provided finance through his will to fund the buying of paintings from 1919 onwards.

Born near Kilmurry in 1837, Joseph inherited a small income which enabled him to devote his life to art studies. He went to Spain in 1878 and lived a lonely life in Madrid until his death in 1919. He was an artist and a collector of works of art, and by all accounts had got together a comprehensive collection of paintings, prints, photographs, books, manuscripts, coins, antiques, and curios.

Joseph's will, read in May 1919, left £14,790 to the Crawford Art School in Cork. Most of the legacy was to be spent in buying works of art for the Cork galleries, and to assist art students of special promise, who were of Munster birth, to travel and study in Europe. With this bequest, under wise direction from Irish experts, more than a hundred paintings in oils or watercolour, and many drawings and sculptures, have been acquired for the Cork gallery and are now on view there. They include works by most of the leading artists including such celebrated painters as Philip Wilson Steer and Frank Brangwyn.

The Irish War of Independence and Civil War slowed down this buying-in process, and it was almost five years before a strategic acquisition programme was

put in place. On 15 January 1924 the *Cork Examiner* published the minutes of the Gibson Bequest subcommittee meeting of 14 January 1924. Draft regulations had been prepared by the chairman, Mr J. J. O'Connor, setting out the procedure concerning the purchase of works of art under the terms of the bequest to be approved. Enquiries had already been made regarding the acquisition of pictures by Jack Butler Yeats and Seán Keating. A painting entitled *Sasha Kropotkin* by Gerard Kelly of the Royal Hibernian Academy was to be purchased for £250. Gerard Kelly was an English oil painter of portraits and landscapes. He became renowned for his portraits of elegant women, his technical genius and colourful, extensive subject matter. He painted Sasha Kropotkin, daughter of the anarchist Prince Peter Kropotkin, and wife of the Russian revolutionary Boris Lebedev.

The draft Gibson Bequest regulation regarding purchase of works of art was set out as follows: (1) Purchases shall be confined to the original works in the following: (a) oils (b) watercolours (c) pastel (d) drawings or studio in chalk, pencil, crayon or pen and ink (e) etchings (f) woodcuts (g) silver point (n) dry point (i) mezzotint (j) sculpture, but that it be the rule not to purchase works in plaster, unless in exceptional circumstances, on account of intrinsic merit, and then only with the intention of having them cast in permanent material; (k) decorative art, e.g. goldsmiths and silversmith's work, stained glass and woodcarving. No purchase could be made by the committee which is not approved by selected advisers or a majority of such. Such advisers could be selected for the special purpose to be sent to exhibitions at the great art centres to select works for

Cabinet of Gibson Bequest Curiosities, present day. (Picture: Crawford Art Gallery, Cork. Photo: Jed Niezgoda)

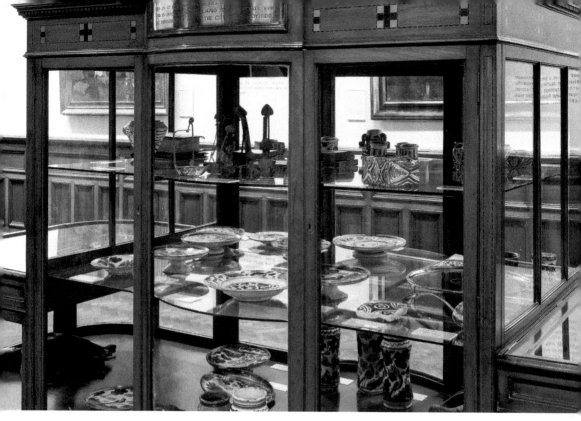

Cabinet of Gibson Bequest Curiosities. (Picture: Crawford Art Gallery, Cork. Photo: Jed Niezgoda).

purchase under the terms of the bequest. Advisors were to submit a signed report with all recommendations for the purchase of works of art. Purchases were to be as far as possible in sequence, as portrait, subject picture, landscape, and sculpture. The recommendations of the advisors with respect to any purchase shall be subject to the approval of the Gibson Bequest subcommittee.

As the years and decades progressed, paintings from British and French contemporary artists were bought, and these now form part of the core of the collections of the Crawford Art Gallery. Local artists were also enabled to travel further afield to such artistic hubs as London, Madrid, Paris and Rome.

The Memory of Sculpture – Seamus Murphy in the City

Born in Greenhills, Burnfort, County Cork, in 1907, Seamus Murphy (1907–75) was one of the foremost stone carvers and sculptors of his time, his work forming part of modern European tradition. From 1922 until 1930 Seamus Murphy worked as an apprentice stone carver at the Marble Art Works of John Aloysius O'Connell in Blackpool, Cork. Seamus received a scholarship in 1931, which enabled him to go to London and then to Paris where he was a student at the Académie Colarossi and studied with the Irish-American sculptor Andrew

O'Connor. Returning home, he established his own workshop in Blackpool. Seamus employed a high level of design and craftsmanship while executing his work, whether plaques, headstones, figures, monuments or memorials. He believed that art had a function regardless of how large or small a commission was. Below are some of his best-known examples.

The 1930s coincided with a revival of Blackpool's fame as an industrial centre for textiles. William Dwyer's Sunbeam Wolsey factory used raw wool and silk to produce socks, underwear and silk hosiery. As a patron of the arts, Dwyer commissioned Seamus to create plaques for his factory buildings at Millfield between Blackpool village and the Commons Road, Youghal and Midleton. These depicted scenes of weaving, spinning and cotton. His greatest commission to Seamus was to the design the Church of the Annunciation in 1945 for the workers in his Sunbeam factory in Blackpool. His work on the church included designing all three altars, the baptismal and holy water fonts as well the carvings of the Annunciation panel, the plaque above the children's altar, the Sacred Heart and a Madonna. His figures convey a sense of reverence while the youthful facial features reveal characteristic emotional intensity. He also designed the bell tower and bell dedicated to William Dwyer's daughter Maeve, who tragically died of an acute case of polio at the young age of twenty-seven.

There are many works by Seamus Murphy across the city and county. For example, in Bishop Lucey Park walk past the preserved section of Cork's

Dreamline by Seamus Murphy located in Fitzgerald's Park. (Kieran McCarthy)

medieval town wall. In front of you is a sculpture of Mary Anne, a well-known onion seller from Cork. During his career, Seamus strove to make sculpture relate to real life in his city. In the foyer of Cork City Hall stand two busts of two of Cork's most famous Lord Mayors, Terence MacSwiney and Tomas MacCurtain.

Seamus Murphy completed the Gaol Cross Memorial adjacent to the portico. His unparalleled skills at letter carving helped Seamus gain significant commissions. The memorial details those who were interred by the British government in the gaol during the Irish War of Independence. There are many Republican memorials created by Seamus across the city and county in locations such as St Finbarr's Cemetery in the city and those at Midleton, Dripsey and Leemount further afield in Ireland, such as that of Countess Markievicz in St Stephen's Green, Dublin, and Thomas MacDonagh in Golden, County Tipperary, can be viewed. Examples include that of Daniel Corkery in St Joseph's Cemetery, Cork, and Seán Ó Riada at Cúl Aodha, County Cork.

In Fitzgerald's Park, Seamus's *Dreamline* is to the rear of the Lord Mayor's Pavilion and Michael Collins, the Irish revolutionary leader, stands proud on a tall plinth across from the museum.

Memorial plaque on ruined portico of the former Cork City Gaol to inmates who died or who were executed in the gaol during the Irish War of Independence. The plaque and carved writing is by Seamus Murphy. (Kieran McCarthy)

Transport and the City

Connecting the Regions – Cork's First Railway Line

The year 1836 marked the opening of Ireland's first railway, between Dublin and Kingstown. A year earlier, in 1835, the plan for a Cork Passage railway was first proposed by Cork-based merchants William Parker and J. C. Besnard. In this year, Passage West had its own dockyard and had become an important harbour port for large deep-sea sailing ships whose cargoes were then transhipped into smaller vessels for the journey upriver to the city. This transhipment would be faster by train. Indeed, in the summer of 1835 a committee was set up to plan the railway, and the Harbour Board, the treasury and other bodies were approached for financial support.

Charles Vignoles was appointed engineer of the venture. The initial plan in 1836 was for the railway to go through Douglas and to build a tunnel underneath Langford Row. However, it was eventually decided that it was cheaper and more level to construct the line along the south bank of the Lee. The line would run close to the south of the Navigation Wall on reclaimed land and remain close to the river to Passage. Preparatory works immediately began at the Cork site and in 1837 the Passage Railway Bill was passed in Westminster. However, by 1838 the project was shelved due to the difficulty of raising finance and the worsening social conditions at the time. In addition, the main shareholders had lost interest and wanted their investments returned. Thus, the idea of a railway was abandoned.

It was only in the mid-1840s that the project was resurrected. This was due to the fact that other railways were being planned for the city. In addition, in 1845, powers were sought for three railways: Cork–Passage Railway; Cork, Blackrock, Passage & Monkstown Railway; and Cork–Kinsale Railway. In the case of the first two requests, their plans were amalgamated to form the Cork, Blackrock & Passage Railway Company in 1846. The relevant legislation was passed in 1846, and in September of that year the company's engineer, Sir John MacNeill, was employed to complete initial survey work. Patrick Moore won the contract for the first 6 miles of the line between Cork and Horsehead, the tender being £38,000. Work began in June 1847.

One of the first problems encountered involved the acquiring of enough finance for purchasing land for the project itself. Land was expensive and it was decided by company officials that the company should also look to the future and buy land that would be used if an expansion occurred. The cost can be estimated at £21,000 per mile.

The original terminus was located at Victoria Road. It was a two-storey structure with a corrugated-iron roof in three parts, a centre and two sides. Cast-iron columns, manufactured by King Street Iron Works, supported the roof. On 27 April 1850, the first trial run of a locomotive took place. The 6.5-mile trip from Passage to Cork took seventeen minutes. A week later, a second trial took place, this time from the city end of the line. This event was first shown in the *Illustrated London News* on 25 May 1850. An engine pulled a first-class carriage which carried the directors of Cork, Blackrock & Passage Railway and a group of merchants. The outward journey took seventeen minutes and lasted just over ten minutes on return. The line was opened to the public on Saturday 8 June 1850 and there was a service of ten trains each way at regular intervals. The departures from Cork to Passage were on the hour while from Passage to the city were every half an hour.

Railway terminus at Cork City's Docks for Cork Blackrock and Passage Railway, *c.* 1860. (Courtesy of Cork Public Museum)

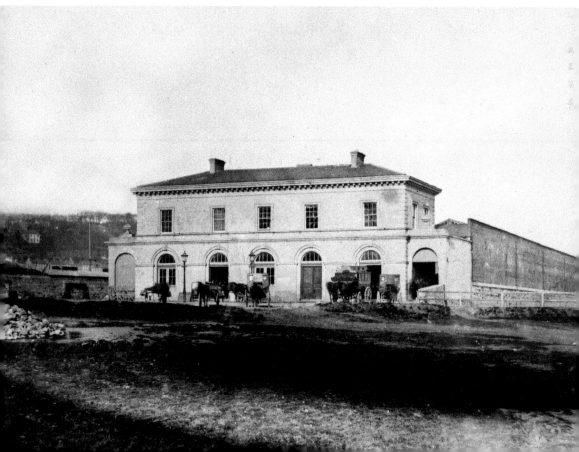

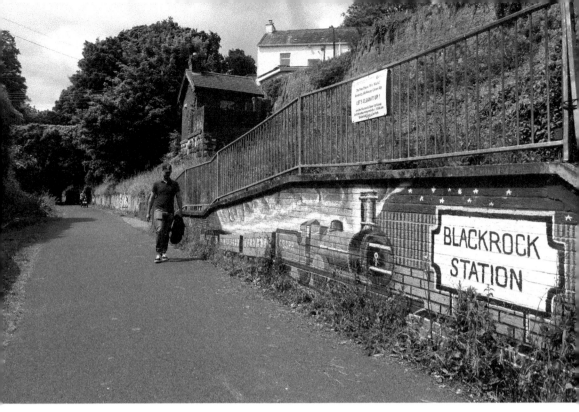

Above: Remains of Blackrock station for Cork Blackrock and Passage Railway, June 2020. (Kieran McCarthy)

Below: Test Run, 25 May 1850, at Blackrock Cutting from the *Illustrated London News*.

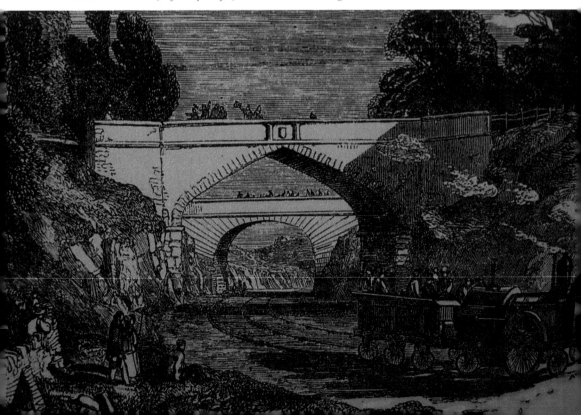

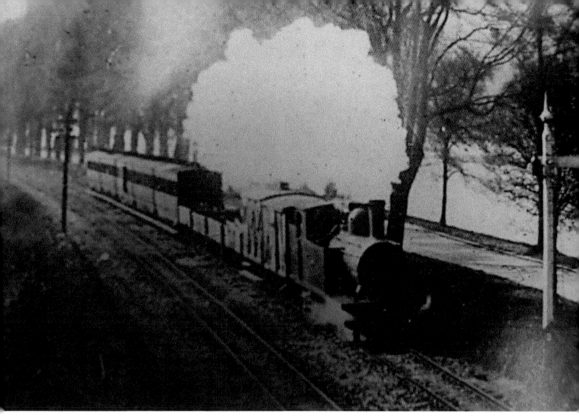

Cork Blackrock and Passage Railway Line on The Marina, *c.* 1930 by Casserley Photography. (Cork City Library)

In 1896, an Act of Parliament enabled the company to extend the line as far as Crosshaven. John Best Leith, Scotland, received the contract for the regauging of the line. Works began in 1897. A new double track was laid between Cork and Blackrock, the only example of a double track in Ireland at the time.

By 1932, increased use of motor cars caused a decline in railway usage. Consequently, the railway was forced to close. Many traces of the Cork–Blackrock line have been destroyed while the Blackrock–Passage section is now a significant pedestrian walkway in Cork City with several platforms and the steel viaduct that crossed the Douglas viaduct still in public view.

The Ford Brand

On 17 January 1984, it was announced that the Ford car assembly plant in Cork was to close, with the loss of 800 jobs. This was the first Ford plant in Europe, set up in 1917 by Henry Ford, whose father was from Cork. The Ford factory left a huge cultural and industrial legacy.

In October 1919, American writer Mr Jay G. Hayden contributed an engaging article for the *Detroit News* on the history and prospects of the Ford tractor factory on the Marina in Cork, which had just opened. His story begins with a brief

sketch of the Ford family in Ballinascarty. He then moves to write about Henry
Ford, who visited Ireland for the first time in 1913. He describes how Henry Ford
introduced the Fordson tractor manufacturing and distributing plant to Cork to
appeal to the European market. Cork, he deemed, was an ideal industrial location
as every commodity needed in the manufacture of tractors could be procured in
Europe and these could come through English ports.

Mr Hayden describes in his article that the experts whom Henry Ford sent to
work out his plans in Cork found many obstacles in their way. The First World
War was in progress and British war regulations imposed a ban against any new
industries which absorbed British materials and labour. Mr Ford's team argued
that the tractors manufactured would do much to support the relieving of the food
shortage. There was also no labour force in Ireland skilled in the way of American
manufacturing methods. Mr Ford argued against these shortcomings, citing the
superiority of his manufacturing methods and the ability to train workers in Cork.

The Cork Park Racecourse, lying beside the River Lee, was selected as the
development site, but the procedure for its acquisition was not straightforward.
The property was owned by the Corporation of Cork but permission to sell the
property had to be sanctioned by the Local Government Board – the British
administrative body which supervised Irish municipal and local affairs. An act
of the British Parliament was required and this took many months before it was

Mr Edward Grace of Messrs Ford's Tractor Works sits on the first Fordson tractor to roll
off the assembly line, 3 July 1919. (Cork City Library)

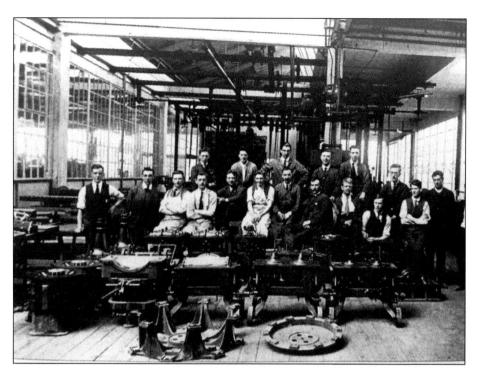

Workers in the machine shop of Messrs Ford's Tractor Works in August 1921. (Cork City Library)

pushed through various technicalities. Construction of the plant did not begin until after the Armistice in November 1918. It was only on 1 July 1919 that the first Irish-assembled tractor was ready to roll off the assembly line. By October 1919, the plant was turning out five tractors a day.

The manager of the Cork plant was Edward Grace, a young businessman from Detroit. He went into the Ford manufacturing business from high school and his industrial education was in the plants at Highland Park and Dearborn. He was sent to Cork with three other superintendents from the Dearborn plant. Every other employee was a Corkman, many of whom had been trained in rural industry but had to be retrained as mechanics.

Buses Cometh

There is evidence that motor charabancs operated in and around Cork immediately prior to the outbreak of war in 1914. Their activities tended to be confined to excursions and tours similar to those operated by the horse-drawn charabancs and 'wagonettes' of the time. One of these early charabanc operators was the Cork and Ballycotton Motor Company, later a prominent Ford dealer trading as the CAB Motor Garage.

Road transport for passengers and freight underwent very rapid development in both Britain and Ireland from 1919 onwards. However, the disturbed state of the country throughout the War of Independence and later the Civil War of 1922/23 inhibited the growth of motorised road transport to some extent. In various parts of the country some charabanc owners started regular services to nearby towns. A number of these services replaced horse-drawn mail contract routes which had their origins in the Bianconi long car network over a century earlier.

Bus services first appeared in Cork City in the summer of 1926. A London bus proprietor, Captain A. P. Morgan, a retired officer of the British Army, financed and introduced four Daimler double-decker forty-four-seater buses under the name Cork Motor Services. City Commissioner Mr Philip Monahan, later to be an eminent City Manager, governed the motor bus affairs. Two routes were operated: College Road to Sunday's Well and Fr Mathew Statue to Collins Barracks. While some business was taken from the tramway services, the operation seems to have lasted for only a few months; by September the buses were no longer running and had been returned to London.

Captain Morgan's pioneering example was followed at various later dates by several local operators. These included Duggan (Pembroke Street to Douglas), Bennett (Statue Blackpool and Magazine Road), Coveney (Statue to Wellington Bridge) and Dwyer's Rocksavage Omnibus Company (Statue to Blackrock).

In October 1926, Swanton's of Cobh began the first inter-urban service into Cork, running from Fermoy under the name Southern Motorways. They later expanded their network to include routes to Cobh, Bandon, Macroom and Blarney before selling their business to the Irish Omnibus Company in 1930.

The example of Southern Motorways was soon followed by other bus companies who started services between Cork and surrounding towns. These included Southern General, Rapid Transit, Rocksavage, Carbery and Cork Omnibus Company. The Irish Omnibus Company (IOC) was formed in Dublin in 1926 and first concentrated on expanding to Limerick before reaching Cork with a Limerick/Cork route in November 1927. Rapid expansion by the IOC in the Cork district followed, and competition intensified between the IOC and the already established local bus owners.

The development of bus services in the city was not without its effects on the electric tramway company, who experienced declining patronage as the use of bus services increased. The city was spreading outwards as a result of new housing developments and buses were able to cater for this expansion in a way which the tramway company could not hope to match without incurring heavy capital expenditure.

By 1931, when the Cork Electric Tramway & Lighting Company decided to cease operation of the system, the Irish Omnibus Company became the dominant operator of bus services in the area, and it was asked to undertake the operation of replacement bus services. This involved the IOC in the operation of the tramway system for a period of six months prior to its final closure in September 1931. During this time a new fleet of Leyland buses, including six double-deckers, was built to cater for the planned expansion of city bus services.

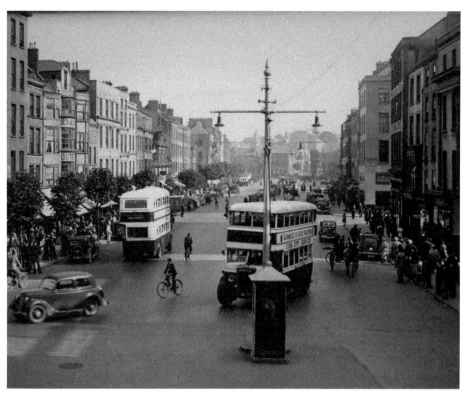

Buses on Grand Parade, 1935. (Irish Examiner Photographic Archive)

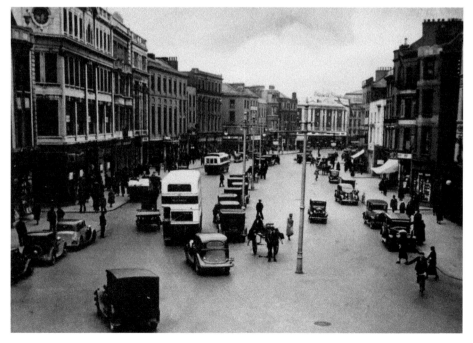

Buses on St Patrick's Street, 1935. (Irish Examiner Photographic Archive)

Cork Airport Opens

In 1934 a group of aviation enthusiasts formed the Cork Aero Club, and one of the principal aims of that body was the establishment of a city airport. In that year members surveyed various likely sites around the city and went into every aspect of the a possible site choice. They finally settled on Farmer's Cross and in the same year, permission was granted by the Minister for Industry and Commerce for the use of Farmer's Cross on the city's southern ridges as a regional airport. The Cork Aero Club could not finance the construction of an airport, which they regarded as a State or local government responsibility. In those years, the estimated cost of establishing an airport at Farmer's Cross was £10,000. That airfield, however, was not then fully licensed because it did not have a sufficient runway to meet with commercial air regulation.

The years passed by with scheme after scheme proposed but nothing materialised. Foynes seaplane base prospered; Rineanna Airport and Dublin Airport were opened but nothing was happening in Cork. The outbreak of the Second World War added to Cork's wait. In the mid-1940s, it began to emerge that Farmer's Cross was not considered suitable as the site for an airport in Cork. Ahanesk, which had been favoured in preference by British experts several years previously, came into the news. This location of 400–500 acres, just 1 mile west of Midleton, seemed to possess all the necessary requisites, and preliminary survey work had been carried out by the County Council in the past.

Sketch drawing for Cork Airport terminal buildings, 1961. (Cork Examiner)

The Department of Industry and Commerce sent observers to Cork to check on meteorological conditions over a period to determine from that aspect the most suitable site for an airport. They began their work at Ahanesk, avoided Farmer's Cross and continued at nearby Ballygarvan. During the wait in the 1950s, the Cork Airways Company was established and they took over the Farmer's Cross airfield from the Cork Aero Club. In May 1948, the Farmer's Cross airfield was officially opened by Taoiseach Liam Cosgrave. With a small set-up the airfield needed funding of £50,000 to extend to create a longer runway space. This finance was not forthcoming.

On 18 January 1954 the department finally announced that the airport would be located at Ballygarvan, 4 miles south of the city. Three years later, in September 1957, the land commission began to acquire land in the vicinity of Ballygarvan to the extent of approximately 420 acres. Once the formalities of taking over the land had been completed, contracts for the construction were signed and the work began.

Cork Airport was opened officially on 16 October 1961 by Taoiseach Seán Lemass. He was also on the first plane to land at the new airport. He was greeted on his arrival by the Lord Mayor of Cork, Anthony Barry, TD and the Minister for Transport, Erskine Childers.

In 2005/6 a new terminal was designed for a capacity of over 5 million passengers and could be expanded when and if the need arose. New routes continued to be added which offered an ever-greater choice to consumers and were evidence of the progress being made by the board, management team and staff at the airport. Operations at the new terminal at Cork Airport were to begin on a phased basis from Tuesday 1 August 2006. Passenger numbers continue to grow.

Opening of Cork Airport, 1961. (Cork City Library)

Institutions and Charities

The Place of Nano Nagle

Nano Nagle Place, like many other heritage buildings in Cork City, is an unexpected oasis in the centre of the bustling city. It is a place that celebrates Nano Nagle's vision of empowerment through education, community inclusion and spiritual engagement for a contemporary world. The complex houses a heritage centre, gardens, a café, and shop. The beautifully regenerated convent buildings are home to several educational charities. The heritage centre opens with a late eighteenth-century John Rocque map of Cork City, which is one of my favourite maps to study.

Nano Nagle was born in Ballygriffin townland, 20 miles north of the city in the parish of Killavullen, in 1718. She was the eldest of seven children of wealthy, well-connected parents. At ten years of age, she left the country to go to school in Paris with her sister Anne. This was the custom at the time of all well-to-do Catholic families.

Nano remained in Paris after her schooling but was brought back to Ireland when her father died. She subsequently went to live with her widowed mother in Dublin. However, a double tragedy struck soon after when her mother died in 1748 and Anne died a year later. Grief-stricken, she returned to Paris where she entered a convent.

After several years of training in Paris, Nano heeded the advice of a Jesuit priest to return again to Ireland, her aim being to help the country's poor children. Returning in 1754, she lived with her brother Joseph and his wife Frances. Among the backdrop of influential charity schools in the city for Protestants, she particularly wanted to provide education and instruction in the Roman Catholic faith.

Nano's first school was in a little rented cabin on Cove Street, now Douglas Street. This school was established in a time when the Penal Laws against Catholic worship were not fully in force. Public teaching of the Catholic religion did carry a large fine plus jail for three months for each offence. She also ran the risk of the political climate changing, further tightening the Penal Laws.

NANO NAGLE
AND EIGHTEENTH-
CENTURY CORK

Cork in the 1750s was a place of great wealth and great poverty. The poorest residents were Catholics who suffered widespread discrimination. Many of them lived in dreadful conditions with little access to food, clothing or education. Nano Nagle, a Catholic woman from a wealthy background, arrived in Cork determined to provide education – both religious and practical – for the poor children of the city, especially girls.

Background image: Merchant's Quay, Cork, from Ireland Illustrated, from original drawings by G. Petrie, W. H. Bartlett & T. M. Baynes, London, 1831.

Above: Entrance to Nano Nagle Place Heritage Centre, present day. (Kieran McCarthy)

Below: Restored convent building, Nano Nagle Place, present day. (Kieran McCarthy)

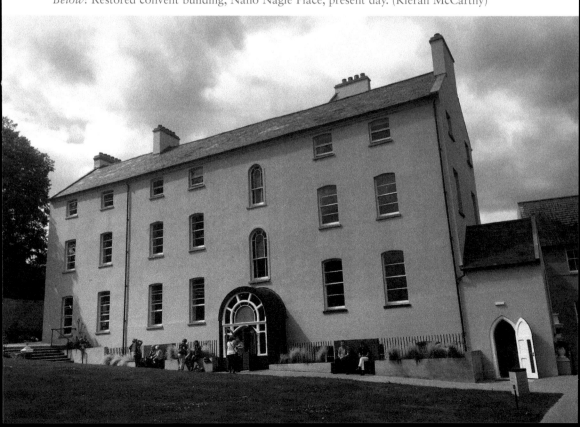

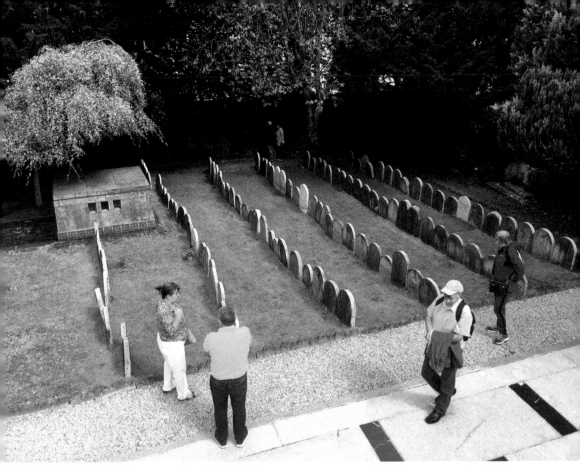

Presentation Sister graveyard, Nano Nagle Place, present day. (Kieran McCarthy)

Such was Nano Nagle's presence in the city that she established her own congregation of sisters in 1776. This was her way of establishing a more permanent basis for her schools. Her foundation was named 'Sisters of the Charitable Instruction of the Sacred Heart of Jesus' (which became the Presentation Order in time). Nano died on 26 April 1784, aged sixty-five.

Cork's Oldest Charity – Sick Poor Society

In the early months of 1820, Bartholomew Murphy and his friend, both working men of the Cathedral Parish, met on their way home from early Mass on Sunday morning. Their conversation turned to the poverty and sickness all round them. One family near him (three being sick) had no food of any sort. They decided that they would go around the locality and collect some aid for them. They were joined by a third man, who, hearing of their determination to do something for the poor, decided to accompany them on their mission of charity.

The collection was far more successful than they anticipated, and the result was they were able to assist not one, but three families. They decided to repeat

the collection on the following Sunday, being assisted by three more volunteers. Henceforth their work was carried out on Sunday after Sunday and always with many additional volunteers coming forward to help. By 1822, the membership stood at twenty-six.

Bishop John Murphy asked that these men should band themselves into a society, which he named the Sick Poor Society. Rules were formed for its better government and management. Notwithstanding the name of the society, the members were always known as the Friendly Brothers. Early records of the society show that in addition to monetary aid to families, often the members had to enlist the assistance of some kind neighbour to look after the wants of those who were unable to do anything for themselves.

In the olden days some of the members did not possess finance themselves, and when financial trouble came their way, the Friendly Brothers were there to assist. An example is given on the death of a member's wife in the year 1839 when his twenty-eight fellow members subscribed monies for her funeral expenses.

In 1848, under the guidance of Bishop Delany, members formed a Rosary Society for the purpose of reciting the rosary each night in the cathedral, an activity that continued for many years.

Gravestone of Bartholomew Murphy, founder member of Cork's Sick Poor Society, at St Joseph's Cemetery, Cork, June 2020. (Kieran McCarthy)

During the society's existence the parish experienced many severe and trying visitations of sickness and want, notably those of cholera, the Great Famine of 1847, smallpox in 1872, and influenza during 1918 and 1919, all of which taxed the members and their funds to the utmost.

The average age of membership from 1822 to 1920 was thirty-five to forty, and the *Cork Examiner* estimated that between 1820 and 1920 upwards of £50,000 was raised – a great achievement as most contributions came in pennies, and very often half pennies.

Some of the older members devoted the greater part of their lives to the work of the society. The *Cork Examiner* article of June 1920 mentions minute books that show that many old members laboured continuously for over fifty years. Founder member Bartholomew Murphy gave fifty-two years' service before he passed away and was buried in the city's St Joseph's Cemetery. Some families were recorded as having four generations involved. Very often, when the funds were exhausted and the weekly collections became unequal to the demands of all applicants, members came to the rescue with their own money.

Offshoot branches were also established in the parishes of SS Peter and Paul and St Finbarr's South Chapel respectively. The South Chapel Society was formed as a confraternity under the patronage of Mary Immaculate on 8 December 1853 – one year before the Immaculate Conception was made an article of faith

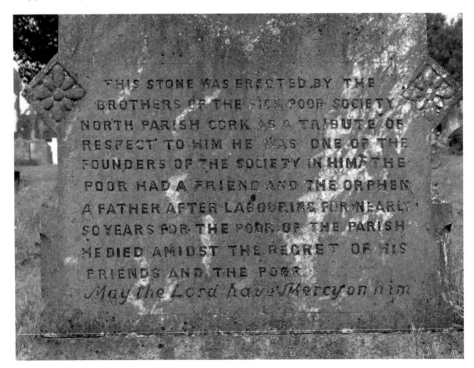

Inscription on gravestone of Bartholomew Murphy at St Joseph's Cemetery, June 2020. (Kieran McCarthy)

Above: Mercy
Hospital, present
day – the city's
former mansion
house. (Kieran
McCarthy)

Right: Entrance to
Mercy Hospital,
June 2020. (Kieran
McCarthy)

Front facade
eighteenth-century windows
of Mercy Hospital, June
2020. (Kieran McCarthy)

by Pope Pius IX. In 1866, the *Cork Examiner* stated that over 900 families or 3,168 individuals were provided with relief in the South Parish, culminating in near 2,000 visits.

In the present day, 200 years after Bartholomew Murphy's initial work, the Sick Poor Society still operates with the help of great volunteers.

The Musical City – Origins of the Barrack Street Band

In early May 1918 the upper section of No. 1 Barrack Street showed signs of serious deterioration and it was ordered by the engineering department of Cork Corporation to be taken down. Today, the gap in the building line is clearly visible in front of Fordes Pub, at the intersection of Sullivan's Quay and South Gate Bridge. The Barrack Street Band started in the upper part of the premises. For nearly eighty years it was the rallying place for large sections of the people of the city's south ward whose interests and values aligned with those of the band.

Founded in 1838 and inspired by the work of Fr Theobald Mathew, the band room and its associated temperance hall were one of the first Cork recruiting spaces for the temperance movement. By the end of 1838, it is argued that

6,000 people were recorded as being on the temperance pledge register in the Cork region due to the springing up of other local recruitment and band spaces. The lead organisers on Fr Mathew's campaign in the early months were James McKenna and William Martin. John Hockings, a leading teetotaller campaigner in Birmingham, was also invited over to lecture to teetotallers in Cork.

By 1839, the temperance movement began to gain popular support in the rest of the country. Branches were organised in surrounding towns. These included Passage, Cobh, Aghada, Whitegate, Blarney, Cloyne, Midleton, Carrigtwohill, Glanmire, Fermoy, Rathcormac, Riverstown, Ladysbridge and Carrigaline. John O'Connell was primarily involved in visiting these branches. Large numbers also began to flock to Cork from the surrounding countryside to take the pledge. By the end of 1839, the reputation of the Cork Temperance Society began to spread further into north Munster, into areas like Limerick.

Within four years of the founding of the Cork Total Abstinence Society, the movement had found its way into every corner of the country. It was not a political movement – indeed, Fr Mathew's principal concern was to keep it clear of politics – but it had, nevertheless, a deep political effect. With their new-found dignity, the converts became more acutely conscious of the weaknesses that surrounded their social state, and this type of thinking inevitably led to more support for the national cause. The temperance movement brought an immediate accession of strength to Daniel O'Connell; his successors benefited from it, and the foundations were laid for better things to follow.

Scholars John Borgonovo and Jack Santino in a book entitled *Public Performances: Studies in the Carnivalesque and Ritualesque* (2017) note that Fr Mathew encouraged the formation of temperance brass bands at the local level to gather crowds for pledge meetings and to offer non-alcoholic entertainment to working classes. Band practice kept men out of the public house, while Sunday band processions and concerts served as wholesome non-alcoholic family events that spread the temperance message. Bands were locally based and had numerous followers who would accompany them on excursions through the city. At the movement's height the city of Cork maintained thirty-three temperance bands, with uniforms financed by Fr Mathew. The instructors of the Barrack Street Temperance Band at this time and up until the 1870s were non-existent, but according to tradition the military bands had a great influence on them. Brass bands often developed alongside reading rooms. Working class self-improvement was a key point.

Local historian Richard T. Cooke in his book *Cork's Barrack Street Silver and Reed Band* (1992) recorded from the band's annals that the No. 1 Barrack Street building comprised three storeys and was constructed at the end of the eighteenth century. The society occupied the first and second floors of the building. On the first floor was the society's reading and recreation room and the second floor housed the band room where instruments and banners were stored. Its rooms were quite spacious and well-lit, with the main entrance on Sullivan's Quay, No. 37.

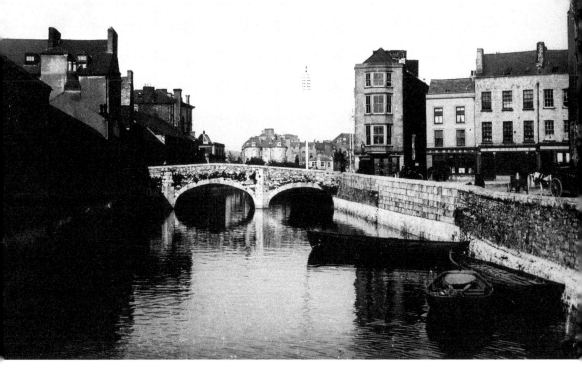

Above: South Gate Bridge *c.* 1900. (Cork City Library)

Below: Site of No. 1 Barrack Street, present day. (Kieran McCarthy)

The building had no water supply, drains or backyard and therefore no outhouse for public convenience. The opening hours of the society were from 7 p.m. to 11 p.m. each evening and it remained open all day Sunday. When the building was condemned in 1918, the Barrack Street Band moved into a city centre building for a time. The band remains an active component of musical life on Barrack Street and in Cork.

GAA Foundations

The Gaelic Athletic Association is an Irish international amateur sporting and cultural organisation focused primarily on promoting indigenous Gaelic games and pastimes. The idea for the GAA was posed by Michael Cusack, who was born in Carron, County Clare, in 1847. A fascinating and complex personality, his passion for Gaelic games was matched only by his love of the unique and beautiful Burren limestone landscape where he was born and raised. He had a love of teaching and after nearly twenty years' experience in different schools he set up his own academy at No. 4 Gardiner's Place in Dublin in 1878. He also had a huge active interest in athletics. In 1879, he was the All Ireland champion at putting 16-pound shot and became champion again in 1882. He deemed that athletic contests needed to encompass more people from the gentry, military and the middle class with artisans and labourers excluded.

Michael Cusack approached Archbishop Thomas Croke of Caiseal who was a strong supporter of Irish nationalism. He had aligned himself with the Irish National Land League during the Land War, and with the chairman of the Irish Parliamentary Party, Charles Stewart Parnell. Maurice Davin, another ally that Michael Cusack recruited, was an outstanding athlete who won international fame in the 1870s when he held numerous world records for running, hurdling, jumping and weight-throwing. He was actively campaigning for a body to control Irish athletics from 1877. He gave his support to Cusack's campaign from the summer of 1884.

The name that Cusack first proposed for the organisation was the Munster Athletic Club. The first meeting was initially supposed to be in Cork. Hurling was widely played around Cork City at the time, with teams such as St Finbarrs, Blackrock, Ballygarvan, Ballinhassig and Cloghroe in regular opposition in challenge contests. However, due to its location, Thurles was chosen and also a new name came to fruition, the Gaelic Athletic Association. The meeting was held on 1 November 1884 with the object of reviving native pastimes such as hurling, football according to Irish rules, running, jumping, weight-throwing, and other athletic pastimes of an Irish character that were in danger of extinction.

Those who attended the first meeting were Michael Cusack, Maurice Davin (who presided), John Wyse Power (editor of the *Leinster Leader*), John McKay (journalist, *Cork Examiner*), T. K. Bracken (a builder from Templemore),

P. J. Ryan (a solicitor from Callan) and Thomas St George McCarthy (an athlete and member of the RIC).

Eleven days after its new establishment, the first Athletic meeting under its auspices was held in Toames, near Macroom. A second meeting to help develop the ideas of the GAA was held in the Victoria Hotel, Cork, on 27 December 1884. The meeting had letters before it from Davitt, Parnell and Dr Croke accepting the invitations to become patrons. Over the following two years a Cork County Board was formed.

From midsummer 1892, the County of Cork Agricultural Society decided to rent out the new grounds to interested groups. One of the first groups to hire the jumping ground was the Church of Ireland Association Cycle Club, for their sports day. It was also decided to allow their competitors to train on the track for a week beforehand as long as it did not interfere with any other activities. Other groups at that time who rented out the space were the Cork Cycle Club, Cork Athletic Club, United Football Club, the Gaelic Athletic Association, the Irish Automobile Club and the Cork Gun Club. Fast forward to 1976 and Páirc Uí Chaoimh opened. It was named after Pádraig Ó Caoimh, who was a native of Cork and was general secretary of the GAA between 1929 and 1964. In 2014, planning permission was passed to create a new modern stadium.

Twenty-five clubs, divisions and colleges currently participate in the Hurling Cork County Championship. The title has been won at least once by nineteen different clubs. The all-time record holders are Blackrock National Hurling Club, who have led the roll of honour since the competition's inception and have won a total of thirty-two titles. Nemo Rangers top the Cork Senior Football Championship with a record eighteen times.

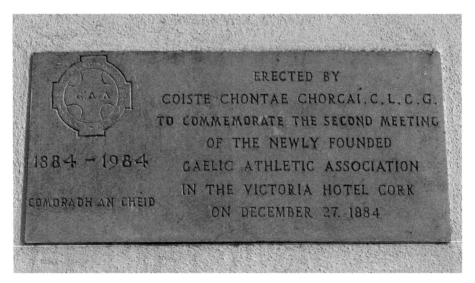

Commemorative GAA plaque at former site of Victoria Hotel, St Patrick's Street, June 2020. (Kieran McCarthy)

Former site of Victoria Hotel, St Patrick's Street, June 2020. (Kieran McCarthy)

Cork possesses thirty All Ireland Senior Hurling Championships with six All Ireland Senior Football Championships. The Cork women's senior camogie team and the women's senior football team have also won their respective All Ireland cups. Twenty-five clubs, divisions and colleges currently participate in the Cork County Championship.

Above: Taking down the 1976 Pairc Ui Chaoimh Stadium, October 2016. (Kieran McCarthy)

Below: Pairc Ui Chaoimh, present day. (Kieran McCarthy)

That Rebel Spirit

The Butter Market of the World

In 1709 the Cork Butter Exchange was created a corporate body by royal charter. For some years prior to that Cork had become a great distributing centre and was sending out barrels of heavily salted butter to England, Portugal, Spain, Italy, the West Indies, and other countries. The very fact that merchants considered it desirable to seek legal authority to create a system of grading and branding is in itself evidence of the importance of the trade.

The Butter Exchange flourished, and by the first quarter of the eighteenth century Cork had become the principal butter mart of the world with exports of over 100,000 barrels or firkins of butter. From the Cork Butter Market during the late eighteenth and nineteenth centuries was exported most of the requirements of the international English provision trade.

Being the only market of the kind in Munster, supplies came to it from all parts of the southern counties including Kerry, Waterford, Tipperary and Limerick. It served a very useful purpose for the agricultural community, as there was then no other avenue through which they could dispose of their produce. Even a series of butter roads was constructed on the approaches to Cork City.

The volume of trade was considerable: every week huge numbers of farmers travelled long distances with their cartloads of butter, receiving in exchange ready cash, which they usually expended before returning home, obtaining supplies in the city's food markets, which included the now famous English Market and Cork's Coal Quay.

The market was under the control of a committee of Merchants. They were largely men of very considerable wealth, and their enterprise and ability ensured that the fullest advantage was taken of the business. The committee comprised butter shippers, butter merchants or receivers, and coopers. Two additional wings were built to the building to cope with the increasing business.

The development of modern transport systems in the late nineteenth century, enabling other countries such as Denmark and others previously out of the running owing to their remoteness, to compete for the English market which up

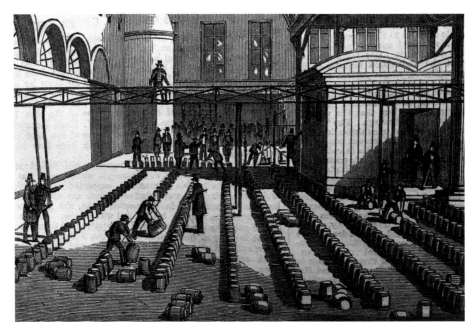

Above: Inspections of butter firkins at Cork Butter Market, 1859, from *Illustrated London News*. (Cork City Library)

Below: Cork Butter Market building, June 2018, during the Shandon Street Festival. (Kieran McCarthy)

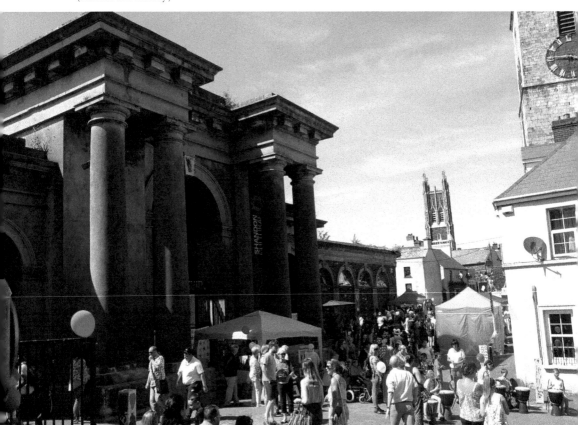

until then was almost monopolized by the Irish trade, dealt a blow to the Cork Butter Market trade.

The market closed in 1924 and was superseded by the advent of the creamery movement in the Irish Free State. The market's three centuries of quality and working together certainly kept Cork in the limelight as a food capital within Ireland, and today it can boast as being an Irish Region of Gastronomy. The Cork Butter Museum is also worth a visit to learn more about the market's story.

Electricity Cometh – Brother Dominic Burke and the North Monastery Science Lab

In the 1880s, talk of a proposed new electric tramline in Cork occurred during the Christian Brothers' Exhibition of the winter of 1889. Held in the Cork Corn Exchange, now the site of the City Hall Fire Brigade, the key organiser was Brother Dominic Burke, a Christian Brother. Brother Burke was a leading educationalist in the city, with a keen interest in all scientific matters. Brother Burke lived and taught at the North Monastery School. He was also the founder and the first principal of its sister school, Christian Brothers' College, St Patrick's Place, Wellington Road. Brother Burke had developed an acute interest in electricity and had watched its development and associated usefulness in the contemporary city very closely.

In the late 1870s, the electromagnetic effect previously demonstrated by Michael Faraday in the 1820s was brought to a new level. Powerful generators for practical use were devised to generate electricity. In 1881, the world's first electric power station went into operation at Godalming in Surrey, England. Gas lamps in the town were replaced by electric lights. However, electricity was expensive to generate and the Surrey station did not last. The world's first really successful power station and electricity distribution network was Thomas Edison's Pearl Street plant in New York, switched on on 4 September 1882. In Cork, Brother Burke had been following the latter developments with interest. On the silver jubilee of Pope Pius IX's episcopacy, Burke honoured the occasion by erecting a huge lamp bulb in the grounds of the North Monastery. Corkonians were much intrigued by the event.

Brother Burke became friends with Gerald Percival, founder of Cork's first firm of commercial electrical contractors, or magnetic engineers as he called them. Percival was a Unitarian or a non-subscribing Presbyterian of the church on Cork's Princes Street. Gerald Percival was treasurer and honorary warden. Both Burke and Percival wished to develop further the concept of electricity in Cork.

The Christian Brothers' Exhibition at the city's corn exchange in 1889 was an ideal event to promote international science and to call for funds for the establishment of technical education schools in Cork. The exhibition took two years to organise and the Brothers showed their international experience

by calling for scientific items from other Christian Brothers based in countries across the world from North and South America, Western Europe, South Africa and Australia. Exhibiting material was readily sent. Stalls demonstrating electric light machinery, telegraphs and telephones, magic lantern displays, and power transmissions attracted huge crowds.

One of the highlights of the exhibition that Brother Burke and Gerald Percival sought for display was an electric-operating tramcar with eight wheels, which ran around the stalls and sideshows of the vast hall. The railway became an attractive novelty when the Catholic Bishop O'Callaghan opened the exhibition on 22 October 1889. A dynamo generated the electric current for the electric tramcar. A straight upright pole rising from the car made contact with the overhead cable. When the exhibition ended, a more enlightened Corporation asked their engineer, M. J. McMullen, to seek out costs for the provision of urban electric lighting and public electric tramcars.

In association with local commercial interests, the Corporation of Cork planned to establish a large electricity-generating plant. The plant would provide public lighting and operate an electric tramcar extending from the city centre to all of the popular suburbs.

Brother Dominic Burke. (North Monastery School Archives)

Former site of late nineteenth-century electricity power house and tramway terminus, now the National Sculpture Factory, June 2020. (Kieran McCarthy)

A Campaign for an Independent University

Under the college presidency of Sir Bertram Windle and through the governing body of University College Cork, a pamphlet was published in the last week of March 1918 highlighting that the time was ripe for demanding an independent university for Munster in the city, and based, of course, on the existing college. The movement was initiated for having an independent university, similar in its constitution to universities in Leeds, Manchester, and other cities in Great Britain.

The year 1918 was exactly eighty years since an independent claim was first proposed by Cork Corporation. In 1902 and 1906, Cork Corporation passed further resolutions in favour of the project. In 1904 and 1908 two large public meetings of the citizens urged autonomy for Cork in the impending university settlement. Presidents of UCC Sir Rowland Blennerhassett and his successor Sir Bertram Windle were consistent advocates of an independent southern university. Under the Irish Universities Act 1908, the name Queen's College Act was changed to University College Cork.

The National University of Ireland (NUI) is a federal system of constituent universities and recognised colleges set up under the Irish Universities Act 1908. In 1918, Cork College was still but an appanage of the National University, and a large amount of its management of academic business generally was pursued in Dublin. Frequent meetings were held in Dublin, meaning a lot of travelling by railway, copious correspondence with all of its possibilities of misunderstandings and friction and clashes of local interests. The Cork University president spent some thirty days each year at meetings in Dublin.

Under a charter and statutes, an overwhelming majority of the representatives of the National University's central council resided in Dublin, which, therefore, had complete control in many important matters and over rival colleges. Dublin College had seventeen representatives, Cork seven, Galway five, and the Crown nominated four (all of whom represented Dublin and three of whom were members of the governing body of Dublin College).

The board of governors highlighted that the number of students attending the college was too small – half as many as those attending the university in Belfast. The number of students attending Cork University was increasing yearly, and the constituting of it as independent college would be a distinct benefit to students.

Map of the campus of University College Cork, 1919. (Cork City Library)

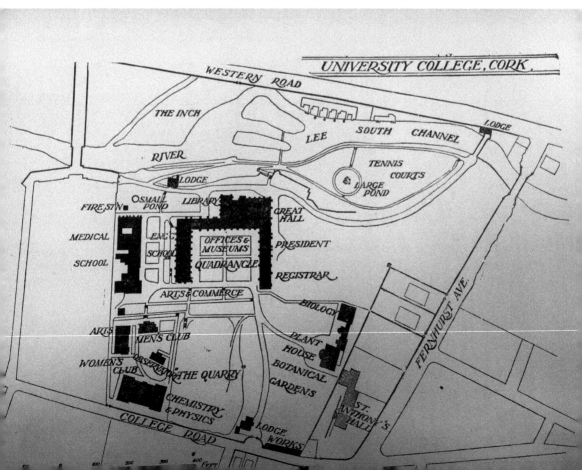

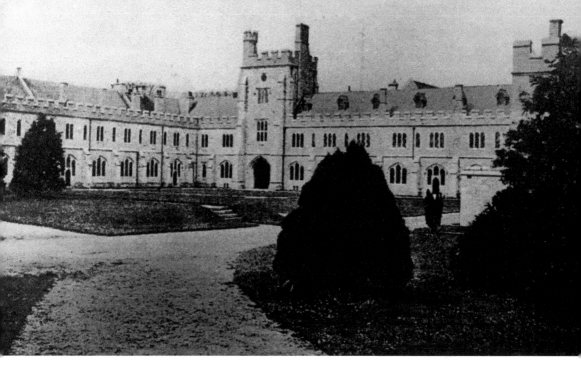

Photo of the quadrangle of University College Cork, early twentieth century. (Cork City Library)

In 1918 Cork had 550 students (110 of whom were women), a greater number of students than that of Belfast College at the time it received its charter.

Since 1908 the college had made great advances in buildings, in its range of instruction, and in the number of its teachers. The medical buildings and the engineering school had been considerably improved, and new laboratories for physics and chemistry had been constructed. At the time of the passing of the Universities Act there were seventeen professors, ten lecturers and eight demonstrators, whereas in 1917 there were thirty-three professors, twenty-three lecturers and ten demonstrators. A Faculty of Commerce had been founded (in association with the Incorporated Cork Chamber of Commerce), as well as a Department of Dentistry. With the aid of a grant from the Cork Corporation, evening lectures for working men had been instituted in connection with the Workers' Education Association.

It was to take until 1997 before a revised Universities Act gave UCC full university independence.

Of Language and Speech – Cork's Gaelic League

On Sunday 14 January 1917 the annual general meeting of the Gaelic League in Cork was held in the 'Grianan', No. 3 Queen Street, now Fr Mathew Street. Mr Tadhg Ó Tuama, a member of the Executive, presided. The Gaelic League offers another lens into the social life of Cork's past. In July 1893, Douglas Hyde

was joint founder, with Eoin MacNeill, of the Gaelic League, which in Irish is 'Conradh na Gaeilge'. Douglas Hyde was president of the organisation until he resigned in 1915. The purpose of the Gaelic League was to keep the Irish language alive and to preserve the Gaelic elements of Ireland's culture. Although the Gaelic League was non-political, it increasingly became identified with political goals due to its membership. The Gaelic League grew dramatically in the early years of the twentieth century. Many Sinn Féin activists joined its 550-plus branches nationwide. Of the sixteen leaders executed post the 1916 Rising, the majority were Gaelic League members and Irish speakers.

At the January 1917 meeting, Honorary Secretary Liam De Róiste detailed that the Gaelic League was reorganizing nationally and there was a revival in Cork following a difficult year of surviving scrutiny of its activities from Westminster. He noted that 'the sympathy of the people was with the language movement' and this was shown by the substantial sums received during Irish Week and the flag day held in November 1916. There were four active city branches with a base at No. 3 Great George Street, now Oliver Plunkett Street. Branches also existed in the principal towns and villages in County Cork. Irish classes for children had been established in the city and there were around sixty children in constant attendance, the average age being seven or eight years. The league was short of

Fr O'Flynn in his twenties/thirties. (North Cathedral Archive)

teachers and suitable accommodation. He deemed the 'teaching of the children was real, solid, fruitful work, the results of which were visible before their eyes'.

During 1916, the Cork branch had also established a scholarship scheme, the object of which was to encourage the speaking of Irish among schoolchildren in city schools. Three young people were sent to the Munster Training College, Ballingeary (est. 1904) for a month's course: one from St Vincent's Convent School, one from St Marie's of the Isle, and one from the North Monastery. They aspired to send at least ten school pupils every year to Irish-speaking districts.

Traditional singing classes took place at the Cork School of Music under Fr Seamus (Christy) Ó Floinn. Ordained in 1909, Fr O'Flynn (1881–1962) had served as a priest at St Finbarr's Seminary, Farranferris (1909–13 and again in 1917) and was chaplain to the Cork Lunatic Asylum. At thirty years of age in 1917, Fr O'Flynn was a strong voice of the Gaelic League in Cork, giving speeches across the city and county, encouraging enrolment before 1917 and beyond.

Fr O'Flynn's personal contributions to local concerts and such functions always ensured their success. In various obituaries in 1962, Fr O'Flynn was detailed as a

Site of An Grianán, the South Parish Branch of the Gaelic League, No. 3 Fr Mathew Street – also the former site of the Fr Mathew Abstinence Hall in Cork. (Kieran McCarthy)

natural musician; he was one of the first to encourage Gregorian chant. Through his personal influence Irish composer and arranger of traditional music Dr Carl Hardebeck was brought to Cork in 1919 and made headmaster of the Cork School of Music as well as Professor of Irish music in UCC in 1922 (returning to Belfast after the Irish Civil War). Fr O'Flynn himself also gave regular assistance at UCC as a teacher at the Irish summer schools in the early days of the Gaelic revival. In a few short years (1924) he would establish a school of drama in a loft above Linehan's Sweet Factory in the Shandon area of Cork City. He would also work with pupils with speech and language impairments.

A Writer's Nest

Cork and its surrounding region possess a rich and colourful literary tradition. The tradition of storytelling is remarked upon by various visitors and travelogue commentators from the seventeenth century onwards. In particular local histories have captured the mirth of novelists, poets, biographers, and short story writers who made their home in Cork and engaged the Cork public. It is the short story tradition, however, which is most synonymous with Cork's literary tradition.

Daniel Corkery (1878–1964) commenced his calling as a writer at the turn of the twentieth century in the columns of David Patrick Moran's brashly polemical nationalist weekly the *Leader*. He developed into a sensitive short story writer, but also wrote a well-regarded novel, *The Threshold of Quiet* (1917). He is best remembered, however, as a propagandist for the Irish Ireland movement, and his two critical studies, in which he discussed these political ideas at length, have been the subject of much controversy. *The Hidden Ireland* (1924) is a study of the eighteenth-century literary remnants of an Irish-language literary culture stretching back almost 2,000 years.

Seán O'Faoláin (1900–91) was a student of Daniel Corkery and was born in the heart of the city in 1900. Sean O'Faoláin's first novel, *A Nest of Simple Folk*, was published in 1933 to great critical acclaim. However, it was to be his short story writing that made him widely known. During his career he penned four novels and numerous shorts stories, and he also wrote a number of biographies, including his own, entitled *Vive Moi!*, in 1965. He penned several travel books and works of literary criticism. During the first half of the 1940s, he edited the distinguished literary magazine *The Bell*. Unfortunately, much of his work was censored, but in 1989, two years before his death, he became a freeman of Cork. The Seán O'Faoláin International Short Story Competition is hosted by the city-based Munster Literature Centre each year.

Frank O'Connor (1903–66) is the pseudonym of Michael Francis O'Donovan, who was another student of Daniel Corkery. Frank worked as a librarian in Sligo and Wicklow. In 1925 he became Librarian of Cork County. In 1938, he resigned from the Cork post and decided to devote himself to literature. He thereafter made

his living through writing, lecturing and broadcasting. He spent a lot of time in England and the USA. O'Connor's work included two novels, the *Life of Michael Collins* and *The Big Fellow* (1937), and translations from Irish literary criticisms and dramatisations. His first volume of short stories was *Guests of the Nation* (1930), which drew on material from his experiences while running dispatches during the War of Independence.

Seán Ó Riordáin (1916–77) was born in Ballyvourney and following the death of his father, the family moved to Inniscarra in 1932. He attended North Monastery CBS, Cork. In 1937 he took a job as clerk with Cork Corporation, but a year later he was diagnosed with tuberculosis and was eventually hospitalised at Doneraile where he wrote his first poem. His poetic collections include *Eireabll Spideóige* (1952), *Brosna* (1964), *Línte Líombó* (1971) and *Tar éis mo Bháis* (1979). In 1965, he resigned from the Corporation due to ill health. In 1967, with Seamus Ó Chonghaile, he published *Rí na hUile*. He worked as a part-time lecturer at University College Cork from 1969. The National University of Ireland conferred him with an honorary D.Litt degree in 1976.

Since the heyday of the 1960s and 1970s a number of short story writers continue to capture the public's imagination. Billy O'Callaghan was born in

Frank O'Connor, writer.
(Cork City Library)

Portrait of Seán
Ó Faoláin, 1963.
(Cork City Library)

Cork in 1974 and is the author of three short story collections. Billy is the winner of a Bord Gáis Energy Irish Book Award for the short story, and twice a recipient of the Arts Council of Ireland's Bursary Award for Literature. A notable nod can be given to Conal Creedon, who is an internationally renowned Cork novelist, short story writer, playwright and broadcaster. He is an award-winning writer and has also written over sixty hours of radio drama, broadcast on RTÉ, Lyric FM, BBC, BBC Radio 4 and BBC World Service.

Theatrical Cork

Corkonians have been entertained in theatres for almost 400 years. During this time, the forms of theatre have altered, reflecting the physical nature of Cork and the changing ideals of the various colonialising groups deciding to settle in the area. In the seventeenth century the theatre within the town walls was based in a converted warehouse. With an absence of historical information, it can be assumed that the repertoire in Cork was similar to theatrical performances occurring in other towns in Ireland and in particular in England.

The first reference to a theatre in eighteenth-century Cork occurred in 1713 when the directors of Smock Alley Theatre, Dublin – Messrs Joseph Ashbury, Thomas Elrington, John Evans, and Thomas Griffith – leased property in the marshes to the east of the walled town, now the area of Oliver Plunkett Street. The directors converted a large room into a playhouse. This was the first Smock Alley Theatre outside Dublin. The associated company of actors of the Smock Alley Theatre performed there for two decades during the summer months. At the beginning of the 1730s, a decision was taken by directors of the Cork Theatre to design a new and proper playhouse.

In 1750, Charles Smith detailed that two theatres existed in the city. The first theatre was located on Duncombes Marsh, around present-day Princes Street. It was known as the Theatre Royal and this hosted the King's Company from Dublin. Here the populace was entertained each year during the midsummer months. The second theatre was built and located in Broad Lane and the performers called themselves the Cork Company. There was also a weekly Assembly and an Academy of Music on Haman's Marsh.

With increasing wealth and elegance came a proposal by the management of the Crow Street Theatre Dublin, headed by Spranger Barry, to create a playhouse more fitting of Ireland's second city. In September 1759, Robert Wood transferred the Theatre Royal patent at Dublin from the Smock Alley Theatre to the Crow Street Theatre. This transfer of patent also affected control of the Theatre Royal at Cork to the Crow Street management in place of the Smock Alley organisation. The new building was located three blocks east of the old Theatre Royal on the same side of George's Street between Morgan's Lane (now Morgan Street) and Five Alley Lane (now Pembroke Street). The Cork General Post Office now occupies the site.

Operas, particularly Italian operas, and theatrical presentations were numerous, with over forty operas performed in Cork between 1850 and 1860 and over 100 plays. Local and visiting theatre companies presented these performances. However, it was often considered necessary to present operas in a shortened form and to add a popular act to the evening's entertainment in order to attract a less sophisticated audience to fill seats. Similarly, in nineteenth-century Dublin, Italian opera flowered through the works of Rossini, Donizetti and Verdi.

As a lecture and assembly hall, the uses of the Athenaeum were limited and in 1874, when the ownership of the building came into the hands of James Scanlan, he remodelled it and added a 700-seat concert hall. In addition, he changed the name to the Munster Hall or Halls. Remodelling made stage performances far more practical, but the premises was more suited to concerts. In 1875, a group of citizens, under the chairmanship of Mr John George McCarthy, MP and local historian, formed the Great and Royal Opera House Company and purchased the Munster Hall from Scanlan. At the same time music as a cultural element in the city began to developed on a professional level.

On 17 September 1877, the Munster Hall became known as Cork Opera House and opened its doors to begin its long illustrious career as Cork's principal theatre. Mr C. J. Phipps of London was commissioned to design the Cork Opera House, which he redesigned and re-equipped as a proper theatre.

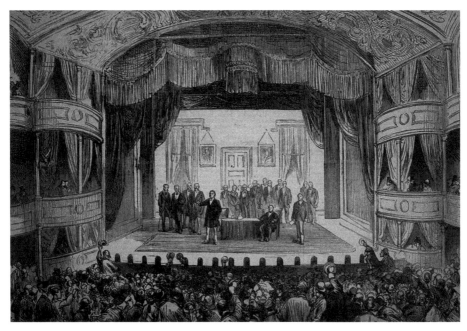

Depiction of interior of Cork Theatre Royal, 1875, from *Illustrated London News*. (Cork City Library)

Sketch of Athenaeum by Frank Sanquest. (Cork City Library)

The Everyman was designed by Mr Henry Brunton and built *c.* 1840 by Mr John O'Connell. Located on the street front of MacCurtain Street, this terraced, two-bay, three-storey construction was originally built as a house, which was part of a group with the adjoining houses to the east and west. In 1897 Dan Lowry opened the building as a luxurious new theatre called The Cork Palace of Varieties. Its origins as a beautiful Victorian theatre are reflected in the interior of the building with its impressive ornate proscenium arch and boxes and a balcony and ceiling composed of decorative plasterwork, which has been restored to its former glory.

The Cork Arts Theatre was founded in 1976 as a club by and for the arts community in Cork. The fondly named 'CAT Club' rapidly became a landmark, serving not only as a venue for amateur and professional companies alike, but also as a favourite meeting place and socialising hub for all arts enthusiasts.

The Musical Heritage

Every well-recorded century in Cork points to music being played in the streets and public halls of the city. Traditional Irish music is important to Cork. It is rooted in famous composers such as Corkman Seán O'Riada (1931–71), who grew up and was educated in County Limerick but returned to UCC as a student in 1948 and studied his great passions, classics and music. He was employed by Radio Eireann as assistant music director, but left in 1956 to explore other musical cultures, eventually studying piano in Paris. He later penned national radio broadcasts entitled *Our Musical Heritage*. In 1959, Seán produced his most well-known work, *Mise Eire*, a short film about Ireland's struggle for freedom. His interpretation of Irish music proved his genius. He revitalised the traditional music scene, enriched the sound of traditional music and brought it to greater audiences.

In the modern day the Cork Folk Festival champions Irish musical tradition but also acoustic tunes and traditional music making from other countries. Such tradition can also be heard across the city's array of historic pub settings and in the many fundraising concerts held in municipal spaces such as the Concert Hall in Cork City Hall.

Of German origin, composer Aloys Fleischmann (1912–92) became the centre of music in Cork for over fifty years, especially in the latter half of the twentieth century. He was professor of music in UCC, a conductor, scholar, teacher and composer who devoted his life and energies to the development of music and art in the city of Cork. He campaigned Cork Corporation to put music on the school curriculum and subsequently a School of Music was built. Fleishman established the Cork Orchestral Society, which gave amateur musicians an opportunity to perform the great works to an appreciative audience. Fleischmann also directed and organised the Cork International Choral Festival, an event that gave local choirs, in particular in rural areas, a forum to compete against other choirs from home and abroad. Each May, the Cork International Choral Festival still sees

world-class performers flock to the city for five days of concerts and competitions across sixty venues.

The art of dance is also important to the city and this is reflected by the number of community dance and theatre schools within the city and the number of students who go on to have successful careers. Dancer Joan Denise Moriarty (1912–92) was instrumental in laying the foundations for the city's love of dance in the twentieth century. At a young age in the 1920s she developed a love of ballet. She trained in London and Paris to become a professional dancer, but due to illness she could not fulfil her dream. In 1941, she returned to Cork where she opened her own dance school in St Patrick's Street and formed the Cork Ballet Group, later the Cork Ballet Company. In 1959 Joan established the Irish Theatre Ballet, which went on tour nationally, but after five years financial problems forced it to close. At this time, the Irish government allocated funds for the establishment of the Irish National Ballet.

Cork can also boast its own rock star culture. Rory Gallagher, musician (1948–95), although born in Ballyshannon in County Donegal, grew up and was

Joan Denise Moriarty.
(Firkin Crane,
Shandon)

Rory Gallagher
at the Manchester
Apollo, 1982.
(Cork City Library)

educated in the heart of Cork City. He pursued his passion for music as soon as he
heard the sound of Chuck Berry, Little Richard, Carl Perkins, Lonnie Donegan and
Elvis Presley on the valve radio, and later listening to American Forces Network
where he heard Woody Guthrie, Leadbelly and Muddy Waters. He was a self-
taught musician and mastered the acoustic guitar in his early teens, progressing
to his renowned (1961) Fender Stratocaster guitar – a Sunburst model purchased
(second hand) at the age of fifteen from Crowley's Music Store in Cork in 1963
for £100. He acknowledged the major influence of several African American
musicians. During his career Rory sold over 30 million albums worldwide and
has a major following in Germany, Austria, Switzerland and Holland. His death
on 14 June 1995 came as a great shock to both his fans and his extended family.
He was a private individual, a rare and great talent, so this was huge loss to the
world of popular music, blues and rock and roll.

A European Capital of Culture – Cork 2005

Following the formal designation of Cork as European Capital of Culture 2005 in May 2002 by the EU Council of Ministers in Brussels, Cork City Council began preparations for a big year. As the smallest city ever to be awarded the prestigious designation of European Capital of Culture, Cork took on the challenge of taking its place alongside some of the great European cities that have previously held the title – Copenhagen, Madrid, Helsinki and Prague, to name but a few.

The public call for ideas attracted over 2,000 local, national and international responses. The resulting programme of near 240 events in the city and county was divided into eight separate categories: architecture; design and visual arts; festivals – film, media and sound; literature publications and conferences; music; residencies and research; sport; and theatre and dance. The delivery of the programme was achieved through partnerships with the city's festivals and existing cultural institutions, as well as community and voluntary groups in Cork and large numbers of cultural practitioners locally, nationally and internationally.

On 8 January 2005, the celebrations were kicked off by President Mary McAleese when five-year-old Danielle Murphy O'Riordain released a balloon at a civic reception in Cork City Hall. 100,000 people came out onto the streets during the day-long festivities to witness spectacular outdoor events, including a re-enactment by Waterford Spraoi of Cork's patron saint St Finbarr slaying a giant serpent – enacting an old folklore event.

During 2005 over 1 million people – seven times the city's population – attended official Cork 2005.

Among the many highlights early in the year were 'La Dona Manca o Barbi-Superestar' by Spanish dance sensation Sol Picó; the Cork 2005 World Writing Series, a major series of readings by literary masters including Nobel Prize laureate Seamus Heaney, Doris Lessing and Kenyan novelist Ngugi wa Thiong'o; and European Quartet Week which included performances from leading international string quartets.

The year continued into the summer as thousands of visitors flocked to 'Airgeadóir', the magnificent exhibition showcasing the work of Cork's silversmiths and goldsmiths over four centuries. Over 500 rowers in 120 coastal rowing boats competed in the first Ocean to City, Ireland's largest ever rowing race. St Luke's Church showcased 'Relocation', the Knitting Map. There was a hugely successful series of outdoor site specific theatre which took to the streets with four European companies including Cork's own Cordadorca. 'Surface Tension' showcased the latest developments in graffiti art, and a lecture by internationally acclaimed architect Daniel Libeskind sold out in twenty-four hours. The year also saw Cork honour Frank O'Connor with the awarding of the first ever Frank O'Connor International Short Story Prize sponsored by O'Flynn Construction to Chinese author Yi-yun Li. The work of James Barry (1741–1806), one of the most significant artists to have been born and trained

European Capital of Culture 2005 banner on Cork City Library. (Kieran McCarthy)

The Knitting Map Project at the crypt of St Luke's Church during Cork's European Capital of Culture year in 2005. (Kieran McCarthy)

in Cork, was exhibited in the Crawford Municipal Art Gallery. Other visual arts highlights included a unique exhibition of collaborative drawings by John Berger, one of the most influential thinkers on culture, and Spanish artist Marisa Camino;'Enlargement', the year-long exhibition at the Cork Vision Centre showcasing art from the enlarged European Union; 'C2', which celebrated the work of over 100 Cork contemporary artists; and 'Forty Shades of Green', at the Lewis Glucksman Gallery.

The world record for the largest gathering of ceilí dancers was broken at the Ceilí Mór; a pilot week of community television was broadcast; the musical traditions of Europe, America, England and Ireland were brought together in the critically acclaimed Music Migrations Series; and, with additional support from Cork 2005, the city's festivals delivered bumper programmes, all contributing to the memorable year.

A huge volume of activity also took place away from the public eye in the wide range of residency and community-based projects. Over 30,000 people, including schoolchildren, trade union members, youth groups, asylum seekers, the sick and the elderly, participated in over 600 creative workshops in the city – an astonishing level of active participation.

Since 2005, the city's cultural element has gotten stronger and stronger and today Cork can boast thirty festivals annually. Visual arts, literature, music, theatre and dance remain strong cultural outputs.

Porter to Photonics – The Prowess of the Tyndall Institute

The Tyndall Institute celebrates Cork's technological prowess. Beamish & Crawford, formerly Cork Porter Brewery (which was set up in 1792), bought the River Lee Porter Brewery in 1813 and also became tenants of the mills. In 1968 University College Cork bought the Lee Maltings from Beamish & Crawford. Work then started on transforming the extent buildings as teaching facilities and for laboratory use for the university laboratory. An indoor sports facility and the original location of the UCC Granary Theatre were also provided for. For over twenty years the complex was home to a wide-ranging set of academic departments.

In 1979 national incentive packages were created to draw the semiconductor manufacturing industry to Ireland. Central government agreed to fund a silicon wafer-fabrication laboratory. It aimed to offer R&D and specialised training facilities for such organisations wishing to set up in Ireland. As a result, in 1981 the National Microelectronics Research Centre (NMRC) commenced at the Lee Maltings in Cork. In 1982 UCC's Professor Gerry Wrixon and his small team took occupancy of a section of the Maltings building referred to as Phase One.

Over a short few years NMRC became one of Ireland's leading research centres and developed a reputation for research excellence within the country and across Europe. Funding was once again sought to expand the facilities.

In 2002 at the NMRC, at the request of central government, an international panel of experts carried out a review and affirmed the international potential of the site. A significant investment of €50 million was made by the Irish government, which enabled the construction of the new research building and the substantial upgrading of the support infrastructure. As part of this investment, the Tyndall National Institute was established in 2004. The facility was renamed after scientist and Carlow man John Tyndall. He created a practical presentation of the transmission of light through a tube of water via multiple internal reflections. He referred to the experiment as the light-pipe. To all intents and purposes John had developed a forerunner of the optical fibre used in modern communications technology.

Fast forward to today and Tyndall's annual reports record the continued hosting of over 450 research scientists, engineers, industry personnel, students and

Former River Lee Porter facility, now the Tyndall Institute, June 2020. (Kieran McCarthy)

The Tyndall Institute, June 2020. (Kieran McCarthy)

support staff, creating an impressive gathering of researchers with state-of-the-art research facilities. The institute conducts groundbreaking research in the areas of micro/nanoelectronics, microsystems, photonics and modelling, theory and design for applications in communications, healthcare, energy, environment and in space.

A Boundary Extension

In February 2018, Tánaiste Simon Coveney announced at a Cork Chamber breakfast that Cork was set to become the fastest-growing city in Ireland over the next twenty years with the population of the city set to almost treble under a combination of Project Ireland 2040 and the extension of the city boundary. Mr Coveney told a Cork Chamber breakfast briefing on the future of Cork under Project Ireland 2040 and the National Development Plan that the population of Cork was expected to grow from its current level of around 120,000 people to between 320,000 and 360,000 by 2040.

On 31 May 2019, Cork City's boundaries extended to effectively add 85,000 new residents to the city. The first extension of the city boundary in over fifty years

welcomed Ballincollig, Glanmire, Douglas, Frankfield, Grange, Blarney, Tower and White's Cross as part of the city.

From June 2019, Cork became home to over 210,000 people. Over 400 public services transferred to Cork city from the county as part of the expansion. Up to 550 km of roads, 990 social housing homes, nine cemeteries and three libraries will become part of the new city. In addition, up to 134 staff transferred to Cork City Council from Cork County Council and a further seventy new posts are also being filled.

Cork is set to play a pivotal role as the economic powerhouse of the southern region of Ireland, as set out in the National Planning Framework – a strategic long-term plan to build and enhance Ireland's economic competitiveness. Cork has an enviable track record in investment attraction. There are some 170 investors already located here including leading industry players like Apple, Dell EMC, Pfizer and Johnson Controls.

The Cork region is home to dynamic start-ups, fostered by a supportive economic ecosystem which includes incubation and co-working spaces, research facilities and a range of advisory and financial supports.

Some 169 multinational companies call Cork home. This is a place of collaboration and creativity, a dynamic economic ecosystem where world-class R&D is hosted in globally recognised research centres and high-level academic institutions work with sector leaders to develop talent for tomorrow's world.

The old and new – boundary extension of May 2019. (Cork City Council)

Old Court Woods, Garryduff, now an amenity run by An Coillte within the Cork City Council boundary. (Kieran McCarthy)

Cork's entrepreneurial culture is fuelling a rapidly growing number of start-ups in sectors like cybersecurity, food, and software development.

Cork's future is bright and filled with opportunities. There is much to celebrate and much to challenge Ireland's southern capital.

Acknowledgements

I would like to sincerely thank the commissioning and editorial staff at Amberley Publishing for continuing to put their faith in my books and for the valuable advice and assistance they always provide. I would like to thank the hard-working staff of Cork City and Cork County libraries for their help. My thanks as well to Daniel Breen and Dara McGrath in Cork Public Museum and Michael Waldron in the Crawford Art Gallery. I would like to express my gratitude to Mairéad, my parents, my family and my public support for continually pushing me to explore, think about and write about Cork City and its regional and its cultural heritage.

About the Author

For over twenty-five years, Kieran has actively promoted Cork's heritage with its various communities and people. He has led and continues to lead successful heritage initiatives through his community talks, city school heritage programmes, walking tours, newspaper articles, books and his work through his heritage consultancy business. For the past twenty-three years, Kieran has written a local heritage column in the *Cork Independent* on the history, geography and its intersection with modern-day life in communities in Cork City and County. Kieran is the author of twenty-seven local history books. He holds a PhD in Geography from National University of Ireland, Cork, and has interests in ideas of landscape, collective memory, narrative and identity structures. In June 2009, May 2014 and May 2019 Kieran was elected as a local government councillor (Independent) to Cork City Council. He is also a member of the European Committee of the Regions. More on Kieran's work can be viewed at www.corkheritage.ie and www.kieranmccarthy.ie.